# SALVADOR DALI

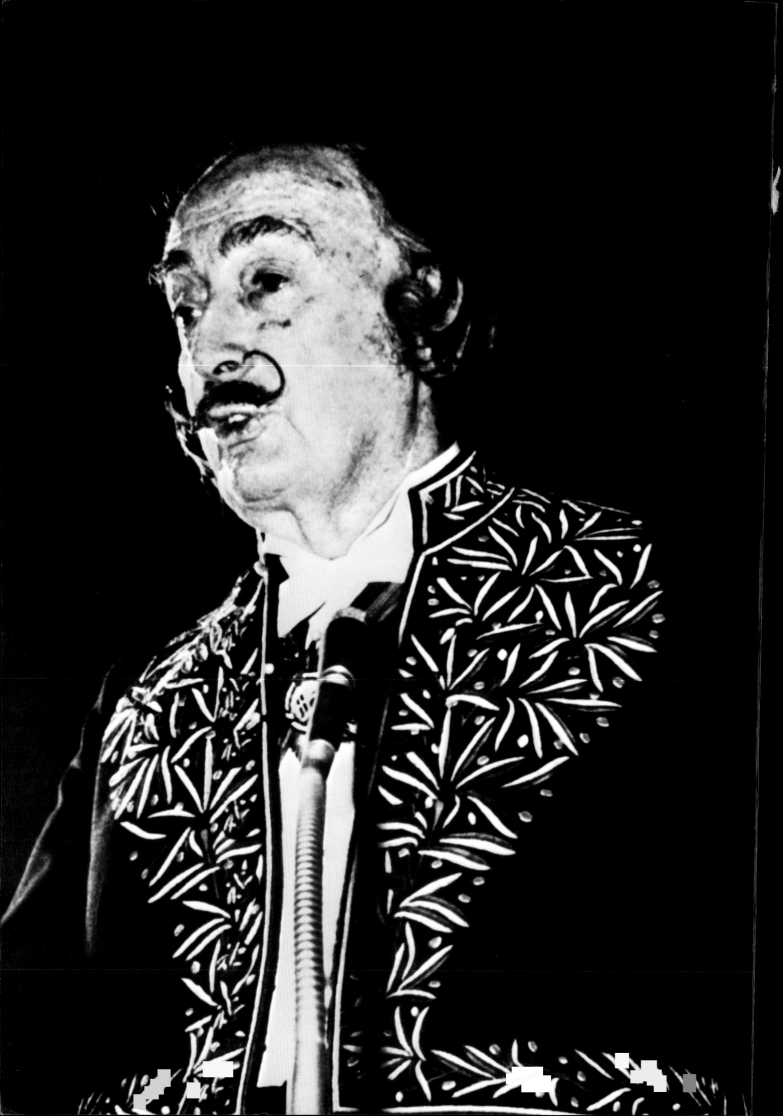

# SALVADOR DALI

THE TATE GALLERY

ISBN 0 905005 37 6
Published by order of the Trustees 1980
for the exhibition of 14 May–29 June 1980
Copyright © 1980 The Tate Gallery
Fourth impression 1984
Illustrations © 1980 A.D.A.G.P.
Designed and published by
Tate Gallery Publications
Millbank, London SWIP 4RG
Printed in Great Britain by Balding + Mansell Limited, Wisbech, Cambs

# Contents

Frontispiece: Salvador Dali at the
Academie des Beaux Arts. Paris. 1979
Photo Jacques Faujour

# Foreword

We are delighted to be able to show in the Tate Gallery this exhibition of Salvador Dali's work which was organised by Monsieur Daniel Abadie for the Musée National d'Art Moderne at the Centre Georges Pompidou in Paris.

We are most grateful to both Monsieur Abadie and to the Centre Georges Pompidou for allowing us to take on the exhibition, which is the first major retrospective show of Dali's work to be mounted in London, and for letting us make use of material from their catalogue.

We have not been able to show some of the constructions and associated material which made the Paris exhibition such an absorbing spectacle, but we hope that our concentration on the paintings and drawings will make more evident the masterly qualities of Dali's work.

Señor Dali himself was most enthusiastic about sending on the exhibition to the Tate and has willingly extended to us the loan of a large number of paintings, and I wish here to say how grateful we are to him and to Señor Enrique Sabater for their generosity.

Finally, I should like to thank all lenders for agreeing to extend their loans to us. Without their generosity the exhibition could not have taken place, and the British public would have lost what will undoubtedly prove to be a memorable experience.

ALAN BOWNESS  *Director*

# SALVADOR DALI

## Simon Wilson

Salvador Dali is undoubtedly the best publicised of all modern artists. He is equally undoubtedly the most widely appreciated, the most truly popular, even if the fascination his art exerts for so many partakes of something of that of the snake for the rabbit. However, Dali's critical reputation has never been really secure, particularly in the case of the work, the bulk of his oeuvre in fact, done since his first major quarrel with the Surrealists in 1935. Some commentators have been even more restrictive: William S. Rubin in his monumental standard work *Dada and Surrealist Art*[1] states: 'The paintings of 1929 are unquestionably Dali's best. In them his style is completely consistent and assured and their complex iconography contains virtually the entire repertory of motifs that he would soon be stringing out more and more programmatically.' Such a narrow view is no longer sustainable. This exhibition, the largest collection of Dali's work ever assembled, now definitively reveals him to be one of the giants of twentieth-century art, a genius of Surrealism, itself one of the most significant and influential of all modern art movements.

Any critical account of the art of Salvador Dali or of Surrealism in general must take as its point of departure Sigmund Freud whose influence on Surrealism and on Dali himself was absolutely fundamental. 'He spoke of Freud as a Christian would speak of the apostles' noted the writer Julien Green, one of Dali's earliest collectors.[2] The increasingly wide dissemination, since the early years of the twentieth century, of Freud's theories and in particular of his theory of the unconscious – that our behaviour is substantially governed by mental processes of which we are not aware – has profoundly affected the conditions of life of our society.

It may be seen as inevitable, given that Freud's work touched on the very well-springs of human activity, that a major art movement directly inspired by his ideas should soon emerge. This, of course, was Surrealism, founded in Paris in October 1924 by the French poet Andre Breton. The movement's foundation was publicly marked by the issue of Breton's *Manifeste du Surréalisme*[3] in which he put forward a vigorous critique of Western society on the grounds of its excessive rationalism and materialism: 'We are still living under the rule of logic . . . the absolute rationalism which remains in fashion permits the consideration of facts only narrowly relevant to our experience. Under the banner of civilisation, under the pretext of progress we have managed to banish from the mind anything which . . . could be pointed to as superstition or fantasy.' Change, however, was beginning to take place and, stated Breton: 'All credit for this must go to the discoveries of Freud. On the evidence of these discoveries a current of opinion is at last developing which will enable the explorer of the human mind to extend his investigations much further . . . *Perhaps the imagination is on the verge of recovering its rights.* If the depths of the mind harbour strange forces capable either of reinforcing or of combating and overwhelming those on the surface *then it is our greatest interest to capture them . . .*'

This then was the Surrealist programme, to tap the creative and imaginative forces of the mind at their source in the unconscious and, through the increase in self knowledge achieved by confronting people with their real nature, to change society. It may be emphasised that it is precisely the extent to which Surrealism through its immense influence on literature, theatre and the cinema, as well as on the arts of painting, sculpture and drawing, has revealed and made familiar to us the working of the unconscious that constitutes the movement's significance. Surrealism, in all its forms, it may be argued, has been the means by which the discoveries of psychoanalysis have been brought to a wide public and built into the very fabric of society. Bringing the public face to face with the unconscious for the first time was bound to produce a shock. The Surrealists were well aware of this, indeed to shock was their deliberate intention: In L'Ane Pourri, 1930, Dali wrote: 'It must be said once and for all, to art critics, artists etc. [sic] that they can expect nothing from the new Surrealist images but disappointment, distaste and repulsion.'[4]

Within the Surrealist movement the nature and impact of Dali's art is exceptional. This is because right from the beginning he was, to adapt a phrase, more Surrealist than the Surrealists, an extremist even in a group whose fundamental doctrine was one of extremism: as Dali himself crisply put it in 1940, after his final break with the group, 'The difference between me and the Surrealists is that I am a Surrealist.'

Surrealism had been defined by André Breton 'once and for all' in the 1924 Manifesto: 'Surrealism, n.m. Pure psychic automatism by which it is proposed to express, either verbally, in writing or in any other way, the real function of thought. Thought's dictation *in the absence of all control exercised by reason and outside all aesthetic or moral pre-occupations*' (present writer's italics). This doctrine of an un-aesthetic and amoral art purely reflecting the patterns of unconscious thought was embraced and pursued more enthusiastically and more consistently by Dali than by any other member of the Surrealist group, resulting in the production of a lifetime's output of works of art which in general visually reveal the unconscious with greater purity, intensity and conviction than any of the others. Freud himself confirmed this when Dali finally met him in London in 1939. In conversation Freud compared Dali's works to those of the Old Masters in which, he said, the unconscious elements are 'of an enigmatic order, hidden in the picture. Your mystery is manifested outright. The picture is but a mechanism to reveal it'.[5]

Dali's oeuvre, furthermore, includes many works dealing with areas of the unconscious where his colleagues feared or fastidiously refused to tread: William S. Rubin has written, 'Whereas the imagery of De Chirico, Ernst and Magritte focused primarily on the familiar common denominators of human psychology, Dali's iconography dealt with more abnormal exacerbated states as for example his obsessions with castration, putrefaction, voyeurism, onanism, coprophilia and impotence.'[6] In sum, Dali's art, it may be said, is the most complete in content and most convincing in form of all the Surrealists. How, the question then arises, did he achieve this? Part of the answer lies of course in Dali's own extraordinary personality. This need not be discussed here in detail; it is more than fully revealed in Dali's copious autobiographical writings particularly the famous *Secret Life of Salvador Dali* first published in 1942.[7] It is admirably summarised however by Dali himself in his celebrated remark made at the opening of his 1934 exhibition at the Wadsworth

Atheneum in Connecticut, U.S.A. 'The only difference between me and a madman is that I am not mad.' It is precisely Dali's strange ability to think like a madman without in fact being mad that has enabled him to generate his unique imagery and from as early as 1929 he was, apparently, elaborating this gift into a fully fledged Surrealist inspirational method. This, the so-called paranoiac-critical method he first described in 1930 in *L'Ane Pourri* and gave a further account of in two short books, *La Femme Visible*, 1930 and perhaps the most important of his writings, *Conquest of the Irrational* of 1935: 'It was in 1929 that Salvador Dali brought his attention to bear upon the internal mechanisms of paranoiac phenomena and envisaged the possibility of an experimental method based on the sudden power of the systematic associations proper to paranoia; this method afterwards became the delirio-critical synthesis which bears the name of paranoiac-critical activity.'[8] Paranoia is a condition in which the sufferer erects a complete delusional system which he has constantly to impose on reality by a process of, in Dali's phrase, 'systematic associations'. In other words paranoia involves the transformation of reality to correspond to unconscious fantasy. Dali, it seems, was able voluntarily to stimulate and set in train such dynamic processes of transformation and this is the essence of his paranoiac-critical method.

One of the great problems for the Surrealists was always the process of obtaining material from the subconscious and in the early years of the movement they adopted a number of procedures, mostly taken from psychoanalysis. One was free association, called by the Surrealists *automatism*, and originally described by Breton in the *Manifesto* as 'a . . . monologue, uttered as rapidly as possible, over which the critical faculty of the subject has no control, which is unencumbered by any reticence, which would be *spoken thought* as far as such a thing is possible . . .' Written down, such a monologue could form the basis of Surrealist literature and certain painters, most notably Dali's friend and early mentor, Joan Miró, adapted the concept to painting. Other methods involved more deliberate or conscious uses of the process of free association, the use of memory, especially childhood memory, and last but very much not least, the use of dreams, Freud's 'royal road to the understanding of the unconscious'. Dali, coming as he did relatively late to Surrealism, inherited this existing methodology and added to it his own 'paranoiac-critical method'. In Dali's view, one sustained by the evidence, the crucial advantage of his method was that it had an active as opposed to passive nature. In *Conquest of the Irrational* Dali wrote of existing Surrealist methods 'These, based on the exclusively passive and receptive role of the Surrealist subject, are now in liquidation and giving place to new Surrealist methods of systematic exploration of the irrational.' In 1934 just before he fell out with Dali, André Breton pronounced in a lecture 'Dali has endowed Surrealism with an instrument of primary importance, the paranoiac-critical method, which has immediately shown itself capable of being applied equally to painting, poetry, the cinema, to the construction of typical Surrealist objects, to fashion, to sculpture, to the history of art and even, if necessary, to all manner of exegesis.'

The other key to the extraordinary power of Dali's art lies in the nature of his technical means. By the time Dali joined the Surrealist group two basic technical approaches had been evolved by the Surrealist painters. One was that used by Miró and others for their automatic works. It involved an essentially spontaneous and improvisatory way of painting and always resulted in imagery that was two-dimensional and of a semi-abstract character usually called *biomorphic* – that is it

evokes or refers to the forms and processes of life. On the other hand the German-born Surrealist Max Ernst had pioneered a quite different approach based on the visual quality of dreams and the example of the 'metaphysical' paintings of the Italian Giorgio de Chirico of the period circa 1912–16, themselves intensely dreamlike. A third vital element in Ernst's painting was his experience of making collages from about 1919 onwards. The compositional freedom of collage, in which wildly disparate images can be brought together in the picture, became fundamental to Surrealist art. This kind of Surrealist painting, often known as *oneiric*, – dream-like – used the traditional representational language of pre-modern art with its three-dimensional illusionism and for this reason is sometimes also referred to as illusionistic Surrealism. In between the two extremes stood the isolated figure of the young French painter Yves Tanguy who made his own discovery of De Chirico but then applied the Italian's dream-like illusionism to the strange biomorphic world of Miro. Dali also inherited the entire range of Surrealist styles bringing with him too an existing grasp of earlier modern art, Cubism in particular, and of the old masters, especially Velasquez, Ingres, Vermeer and seventeenth-century Dutch still-life. But one further ingredient contributed vitally to the startling new synthesis of these elements that first appeared in Dali's painting in 1929: *art pompier*. This term refers to the dead, 'academic' condition that the old master tradition of painting had fallen into by the mid-nineteenth century in the official art schools and *salons* (exhibitions) of Europe. It was against this that the Realists and Impressionists revolted in the eighteen-fifties and sixties and founded a new tradition. The *pompier* painters, like the Frenchman Ernest Meissonier (1815–1891) particularly admired by Dali, often possessed dazzling illusionistic skills but very little else, and illusionism itself was precisely one of the elements of academic art most despised and rejected by the early moderns. The dominant aesthetic of modern art stresses the flatness of the picture – its real nature – and the innate qualities of colour, line, form and texture independent of whatever reference they may make (if any) to the visible world. It is one of the many fascinating and original aspects of Dali's artistic personality that he was able to look back at this discredited area of the art of the past and use it to fuel the continuing evolution of modernism. Its value to him was, precisely, its refined illusionism which enabled him to present his material from the unconscious, his 'images of concrete irrationality', as he called them, with maximum intensity and conviction and, it need perhaps hardly be added, in a form which has helped to give his art its exceptionally broad appeal. To some extent of course these considerations apply to the other 'illusionist' Surrealists but the degree of Dali's illusionism is undoubtedly greater than that of all the others with the exception of Tanguy, whose influence on Dali was the most important of all.

In *Conquest of the Irrational* Dali wrote 'My whole ambition in the pictorial domain is to materialise the images of concrete irrationality with the most imperialist fury of precision in order that the world of imagination and of concrete irrationality may be as objectively evident, of the same consistency, of the same durability, of the same persuasive, cognoscitive and communicable thickness as that of the ex-terior world of phenomenal reality.' And, he continued, 'The illusionism of the most abjectly *arriviste* and irresistible imitative art, the usual paralysing tricks of trompe l'oeil, the most analytically narrative and discredited academicism, can all become sublime hierarchies of thought and the means of approach to new exactitudes of

concrete irrationality.' He then proceeds to give his now celebrated description of his paintings as 'Instantaneous and hand-done colour photography of the superfine, extravagant, extra-plastic, extra pictorial, unexplored, super-pictorial, super-plastic, deceptive, hyper-normal and sickly images of concrete irrationality.'

The adoption of a visual system so completely antithetical to the dominant aesthetic of modern art carried with it for Dali and the other 'illusionists' one other advantage: their paintings answered very closely Breton's call in the Manifesto for an art 'outside all *aesthetic* or moral concerns.' It may be added that it is a nice irony that a style that reached its apogee in the nineteenth century as the official style of the ruling classes, comfortably reflecting their own world view, should be used by the Surrealists to produce an art of subversive and revolutionary intent.

Salvador Dali was born on the 11 May 1904, the son of a notary in the town of Figueras in the northern part of Catalonia, a province of Spain with a language and important culture of its own and a strong sense of independence. Dali was evidently a child prodigy for his earliest recorded painting is a landscape in oils supposed to have been done in 1910 when he was six! An important step in his art education was the beginning, in the summer of 1914, of visits to family friends, the Pichots. In *The Secret Life of Salvador Dali* Dali recorded 'This family has played an important role in my life and has had great influence on it . . . all of them were artists and possessed great gifts and an unerring taste.' For Dali the most important of the family was Ramon (1872–1925) a painter and friend of Picasso whose works hung all over the dining room walls of the Pichot family house. Dali wrote '. . . breakfasts were my discovery of French Impressionism, the school of painting which has in fact made the deepest impression on me in my life because it represented my first contact with an anti-academic and revolutionary aesthetic theory.' Dali's formal art education began in 1921 when he went to the San Fernando Academy in Madrid where he had a stormy career, despising his teachers, developing his outrageous public persona, being suspended for a year (1923–4) and imprisoned for thirty-five days as a result of a minor riot of students for which he was held responsible. Finally he was permanently expelled from the school in October 1926 after publicly refusing to take his examination, declaring 'None of the professors of the School of San Fernando being competent to judge me, I withdraw.'

The 'house style' of the Madrid school was apparently a cautious post-impressionism – quite advanced for such an institution at that date. Dali, however, had already discovered cubism and simultaneously was becoming more and more interested in the old masters and the *pompier* painters. It was his teachers' rejection of both that earned Dali's contempt.

Dali's work of his final year at Madrid and the year following, the period 1925–7, reveals a truly impressive developing talent. The 'Bread basket' of 1926 (illustration xxxi) is an immaculate exercise in traditional still-life painting. His assimilation of the influence of Ingres, and, it seems, the great German romantic Caspar David Friedrich, is admirably displayed in 'Seated girl seen from the back' of 1925 (cat. 12) and the haunting 'Girl standing at a window' of the same year (cat. 11).

Equally haunting is the view of the sea and cliffs with a nude bather at Penya-Segats of 1926 (cat. 14). The composition suggests that Dali had already discovered reproductions of the works of the English Pre-Raphaelite painters and their associates; specifically, 'Penya-Segats' is strongly reminiscent of William Dyce's

'Pegwell Bay' (Tate Gallery). Later, after visiting England for the first time on the occasion of the International Surrealist Exhibition in London in 1936 Dali published an article in the Surrealist review *Minotaure* (issue no.8) entitled 'The Spectral Surrealism of the Pre-Raphaelite Eternal Feminine'.

Dali's cubist paintings are among the most striking of all these early works. The big 'Still-life by moonlight' of 1927 (cat. 22) for example is a masterly piece of late cubism, decorative and harmonious. Paintings like this together with those of the same period done in the 'abstract' Surrealist manner of Miró and André Masson (cat. 25, 26) show that Dali could easily have become a very different kind of painter, one whose work would have been perceived as much more in the mainstream of modern art. But Dali turned deliberately away from the path of abstraction and was later to call it 'this model mental debility' (*Conquest of the Irrational*). However, it must be stressed that Dali never ceased to admire Picasso for the invention of Cubism:
'the biological and dramatic

phenomenon

which constitutes the cubism

of

Picasso

was

the first great imaginative cannibalism

surpassing the experimental ambition

of modern mathematical physics'.[9]

It was out of this 'abstract' phase that Dali's mature style directly developed and his complete understanding and assimilation of the principles of cubism and abstraction is a crucial ingredient in it.

In 1928 illusionism of form and space and elements of literal imagery began to enter those of his works influenced by Miró and Masson and at the same time he was clearly increasingly inspired by the illusionistic biomorphism of Tanguy. The result was a series of remarkable paintings (cats. 27–31) possessing the hallucinatory intensity of Dali's mature work; in them the swarming imagery of Miró and Tanguy is beginning to take on a highly personal, *Dalinian*, quality. Not the least remarkable aspect of these works is their lyrical colour, fluid calligraphic drawing, sensitive handling and approach to texture. Many of them, 'Senility' (cat. 31) of 1928 perhaps outstandingly, are very beautiful. This was still the heritage of Miró which Dali was definitively to abandon the next year, 1929. He was never again to do an 'aesthetic' painting.

It was in 1928 that Dali finally visited Paris for the first time and met the Surrealists. He made a brief trip early in the year and then returned later to stay until the beginning of 1929. On the first trip Dali paid a respectful call on Picasso. 'I have come to see you' he said 'before visiting the Louvre.' 'You are quite right' replied Picasso.[10] During the winter of 1928–9 in Paris, Dali's painting rapidly evolved and sometime early in 1929 Dali recalls 'I met Robert Desnos [Surrealist writer] one evening at the Coupole and afterwards he invited me up to his place. I always carried a painting under my arm as a sample. He wanted to buy the one I had but he had no money. He certainly understood the originality of my painting which was called "The first day of spring" (illustration i) and in which libidinous pleasure was described in symbols of a surprising objectivity. He said "It's like nothing that is being done in

Paris".' This painting and the ones that followed it, painted throughout the summer of 1929 after Dali's return to Spain (illustrations ii, iii & iv and cats. 32, 35–6) mark his first maturity. They are, as Desnos rightly remarked, entirely original – a new form of painting in which the traditions of literal illusionistic representation of the visible world are combined with the freedoms of cubism and abstraction to forge a visual language uniquely well fitted for the pictorial realisation of the invisible world of the unconscious. The creation of this new language constitutes an important part of Dali's contribution to modern art.

Dali's stay in Paris also saw the first showing of the celebrated film he made in collaboration with the young film maker Luis Buñuel in 1928 – *Un Chien Andalou* (An Andalusian Dog). There seems little reason to doubt Dali's claim that he was the dominant creative spirit behind this extraordinary and seminal film which introduced Surrealism to its most important medium after painting, the cinema. In 1931 Dali wrote a scenario for a full length film by Buñuel, *L'Age D'Or* which was however eventually made without his participation and marks the beginning of Buñuel's independent development into one of the cinema's greatest *auteurs*. Since then Dali has retained an intermittent involvement with the cinema, creating the dream sequence for Hitchcock's *Spellbound* (1936) setting up a project for a film with Disney which sadly was never realised and producing a number of films of his own, *The Prodigious Adventure of the Lacemaker and the Rhinoceros* (started 1954, still in progress) *Voyage in Outer Mongolia* (1974) and most recently he finally completed *Babaouo* (1978) from a scenario of 1932.

At the end of 1929 Dali returned again to Paris for his first one man exhibition there, at the Galerie Goemans. It opened on 20 November in the absence of the artist who had gone off back to Spain with Gala, wife of his friend the Surrealist poet, Paul Eluard. Dali had been pursuing a torrid love affair with her since the summer. She quickly became, and has remained, of cardinal importance in his life and art. The exhibition, Dali later learned, had been a sell out; it marked the beginning of his public success and shot him into the front ranks of the Surrealist group at a difficult moment in the movement's history. Maurice Nadeau, the group's first historian later wrote 'Yet new forces would replace the old ones. In the evening of this epoch rose the star of Salvador Dali, whose personality and activity were to cause the entire movement to take a new step.'[11] The catalogue of the exhibition contained an essay by André Breton in which he wrote 'It is perhaps with Dali that for the first time the windows of the mind are opened fully wide.'

At this point the question of the interpretation of Dali's paintings arises. Some commentators have attempted specific Freudian readings of them and, much more usefully, over the years Dali himself has provided a variety of information about many. However, as the public response to Dali proves and as Dali himself insists, they do not require interpretation. In a lecture (a 'euphonic announcement') given at the Museum of Modern Art, New York in 1934[12] Dali pronounced 'To understand an *aesthetic* picture, training in appreciation is necessary, cultural and intellectual preparation. *For Surrealism the only requisite is a receptive and intuitive human being.*' This, Dali further argued, is true because Surrealist art deals with what he called 'the great vital constants' of human existence, that is those universal elements which dominate the unconscious and are common to all of us. He said, 'The Subconscious has a symbolic language that is truly a universal language for it does not depend on

education or culture or intelligence but speaks with the vocabulary of the great vital constants, sexual instinct, sense of death, physical notion of the enigma of space – these vital constants are universally echoed in every human being.' Dali's own art, like that of his fellow surrealists, does in fact refer extensively to sex, to death and to the eternal mystery of space and the infinite. Only, as we have seen, he pursues his explorations, especially in the realm of sex, into more remote regions. The paintings of 1929 are the first of a truly amazing series revealing with extraordinary thoroughness and often in unprecedently frank detail an immense range of sexual preoccupations all the way from coprophilia (among other things) in 'The lugubrious game' (illustration iv) to masturbation and fellatio in 'The great masturbator' (cat. 35). The series extends into the early 1930s with 'William Tell' (illustration xxx), the most important of a number of works in which Dali used the legend of Tell as a framework for dealing with the Oedipus complex and the fear of castration; it reaches a climax with the great 'Birth of liquid desires' of 1932 (illustration vii) which unfortunately was not available for the exhibition. There are other works by Dali, occurring throughout his career, which refer, like 'William Tell', to well known myths or legends, including Christian myth. Examples are 'Metamorphosis of Narcissus' of 1937 (cat. 156), 'The temptation of St Anthony' of 1946 (cat. 199) and the celebrated 'Christ of St John of the cross' of 1951 (cat. 215). Occasionally there has been reference to major political events as in 'Soft construction with boiled beans, Premonition of civil war' of 1936 (illustration xiv) or 'The enigma of Hitler' of 1937 (cat. 160). And in one instance at least Dali has erected his own mythical structure – in 1932 he became obsessed with the famous painting in the Louvre, 'The Angelus' (1857–9) by Jean-Francois Millet and wrote a book about it entitled 'The tragic Myth of the Angelus of Millet'.[13] He also made, around 1933–4, a whole group of paintings inspired by this obsession (cats. 85–87). Works such as these possess an extra dimension of meaning which gives them a special place in Dali's *oeuvre* and some of his greatest paintings are among them.

By the time he painted 'William Tell' in 1932 Dali had well under way another series of paintings, very different from the sexual ones. Starting in 1930 he began to paint landscapes, haunted, melancholy, empty except for an occasional jagged outcrop of rock or a ruin and peopled only by figures expressing intense loneliness and solitude (cats. 72, 105). These compelling paintings extend into the twentieth century the great tradition of European romantic landscape painting founded by Caspar David Friedrich and Turner in the early nineteenth century in which the central theme is man's awed contemplation of the immensity of nature, of the infinity of time and space, and his realisation of his own appalling isolation in it. Related to these is 'The persistence of memory' of 1931 (cat. 64) in which the derelict landscape is peopled with three soft watches, one of them draped over a melted human face (recognisably that of Dali) which in turn flops over a small outcrop of rocks. This is rightly one of Dali's most famous paintings, one of the strangest statements in art of man's obsession with the nature of time. It also marks the establishment in his art of the important and effective device of the evocation of softness.

The theme of the haunted landscape continues in a group of beach scenes done at Rosas on the Costa Brava between 1934 and 1936 (illustration xi, cats. 99, 100, 102–4) and in certain works which can be associated with these (e.g. cats. 97–8, 106). These paintings are characterised by an intense luminosity in which figures

and objects appear with all the quality of a mirage or hallucination.

In December 1931 in the third issue of the Surrealist magazine 'Le Surréalisme au Service de la Révolution' Dali published an article titled *Surrealist Objects* and thereby gave a vital stimulus to a fascinating and important area of Surrealist art – object making. The Surrealist object is essentially a three-dimensional collage using existing real elements and, Dali wrote, 'The Surrealist object is one that is absolutely useless from the practical and rational point of view, created wholly for the purpose of materialising in a fetishistic way, with the maximum of tangible reality, ideas and fantasies having a delirious character.' The Surrealist object has in fact a long history going back to the *ready-mades* produced by Marcel Duchamp from 1912, but only after Dali's article did object-making become a regular and integral part of Surrealist activity. Dali's own objects include most notably the simple but effective 'Lobster telephone', the 'Venus de Milo with drawers' and the famous couch in the shape of Mae West's lips (cats. 119, 120, 132).

In 1936–7 a change becomes discernible in the general visual character of Dali's paintings – they increasingly tend to consist of strange monolithic structures placed centrally in the usual bleak landscapes. With this development his art takes on a new depth of power, a quality of monumentality and a new richness and complexity of meaning; from 1936–8 he painted a sequence of imposing masterpieces which mark the full flowering of his genius. Among them is the melting head propped up by a multitude of crutches in 'Sleep' of 1937 (cat. 155) which can be seen as a companion to the soft watches of 'The persistence of memory' (cat. 64) and is almost as famous. Again, justly so, for it is a strikingly original image of an important human psychological state, sleep, and especially, the dream, that was also, of course, of central concern to the Surrealists. Dali's crutches have always aroused more curiosity than any other symbol in his art. In *The Secret Life* Dali wrote 'My symbol of the crutch so adequately fitted and continues to fit into the unconscious myths of our time that, far from tiring us, this fetish has come to please everyone more and more. And curiously enough the more crutches I put everywhere so that one would have thought people had at last become bored by or inured to this object the more everyone wondered with whetted curiosity, "Why so many crutches?"' That the general symbolism of the crutches is social and political is made clear by Dali in *The Secret Life* when he describes how after settling in Paris in 1929 he begins to meet the upper classes, to move in 'Society' and becomes acutely aware of its decadence and vulnerability to revolutionary change. Dali, like many great artists and writers from the early nineteenth century onwards is a dandy for whom the idea of aristocracy holds a romantic fascination although, as he makes clear, this does not prevent him viewing it in a cynical and satirical spirit: 'I decided to join forces with the groups of invalids whose snobbism propped up a decadent aristocracy which still stuck to its traditional attitude. But I had the original idea of not coming with empty hands, like all the rest. I arrived, in fact, with my arms loaded with crutches! One thing I realised immediately. It would take quantities and quantities of crutches to give a semblance of solidity to all that.'

In the case of 'Sleep', the crutches, Dali tells us, have a more specific role: 'I have often imagined the monster of sleep as a heavy, giant head with a tapering body held up by the crutches of reality. When the crutches break we have the sensation of "falling".' This sensation, common just at the moment of going to sleep, Dali suggests

is a memory of the expulsion from the womb at birth. In the caption to the reproduction of 'Sleep' in *The Secret Life* Dali also noted: 'painting in which I express with maximum intensity the anguish induced by empty space'.

Another of these paintings, 'Swans reflecting elephants' of 1937, (cat. 153) offers one of the most perfect examples of a pictorial device fundamental to Dali's art from 1929 on but which reached its fullest development in some of the works of 1936–8. This is the double or 'paranoic' image which was described in Dali's first account of the paranoiac-critical method, *L'Ane Pourri* of 1930: 'it is by a specifically paranoic procedure that it has been possible to obtain a double image: that is the image of an object which, without the least figurative or anatomical modification can at the same time represent another, absolutely different object . . .'

If 'Swans reflecting elephants' presents a paranoic image purely for its own fascinating sake, in the 'Metamorphosis of Narcissus' of 1937 (cat. 156) the double image becomes the means of expressing a theme of profound significance. Indeed this painting, one of that special category of mythological or political works already mentioned (p. 16), is a work to which Dali evidently attached particular importance for it was accompanied at the time of its completion by the publication of a book of the same title. The book consists mainly of a long poem. At the beginning is the announcement 'THE FIRST POEM AND THE FIRST PICTURE OBTAINED ENTIRELY THROUGH THE INTEGRAL APPLICATION OF THE PARANOIAC-CRITICAL METHOD.' It also contains a clue as to the origin of the painting, a clue which enables us here to glimpse something of the workings of the paranoiac-critical method. The clue is in the form of a few lines of dialogue between two fishermen of Port-Lligat, a small fishing village near Cadaqués and Dali's home since 1930. They are evidently speaking of a slightly demented villager:

First fisherman:     What's the matter with that chap staring at
                     himself in a mirror all day?
Second fisherman: If you really want to know he's got a bulb in
                     his head.

Dali explains '"A bulb in the head" in Catalan corresponds exactly with the psychoanalytic notion of "complex"'. If a man had a bulb in his head it might break into flower at any moment, Narcissus!' Dali's instant association of the mirror with the Greek myth followed by the mental jump of his transformation of the Catalan phrase into the image of the flower sprouting from Narcissus' head, vividly evoke the dynamic processes of paranoiac thought. But the most extraordinary transformation of all is that of the boy's body into the strange fossil hand holding an egg. Here can be seen precisely the way in which paranoiac thought transforms reality to conform with unconscious obsessions. Furthermore, by a masterly stroke of illusionism, a virtuoso piece of painting, Dali makes the change take place before our eyes as our attention switches from the figure in the pool, brilliantly caught at precisely the half-way point from boy to hand, to the final monument at the poolside. Thematically 'Metamorphosis of Narcissus' is a complex and fascinating work. It embodies the myth which provided Dali with the profoundly important psychological element of narcissism or self-love, but beyond that, and like the myth, the painting is a poetic expression of the mystery of the cycle of life, the progress from birth to death to decay to rebirth. In this respect, it may be said, it makes a distinguished addition to one of the great traditions – cycle of life painting – of European art.

Among the remaining masterpieces of the 1936–8 period are two groups with political themes. First, a pair of paintings of 1936–7, 'Soft construction with boiled beans . . .' (illustration xiv) and 'Autumn cannibalism' (cat. 158) dealing with the Spanish Civil War, and then a series of five inspired by Hitler and the Munich crisis of 1938. Of these only two were available for the exhibition, 'The enigma of Hitler', 1937, (cat. 160) and 'Mountain lake', 1938, (cat. 161).

'Soft construction . . .' and 'Autumn cannibalism' each offer a visual metaphor for civil war of astonishing power and originality. Of 'Soft construction', painted according to Dali shortly before the outbreak of the war, he wrote: 'I showed a vast human body breaking out into monstrous excrescences of arms and legs tearing at one another in a delirium of autostrangulation . . .' Of 'Autumn cannibalism' he said: 'These Iberian beings mutually devouring each other correspond to the pathos of civil war considered as a pure phenomenon of natural history.' Very interestingly, however, 'Autumn cannibalism' with its mutually devouring couple appears to have a whole other frame of reference, namely Dali's first physical contact with Gala in the autumn of 1929 as recounted in *The Secret Life*: 'And this first kiss mixed with tears and saliva, punctuated by the audible contact of our teeth and furiously working tongues, touched only the fringe of the libidinous famine that made us bite and eat everything to the last!'

The telephones in 'The enigma of Hitler and Mountain lake' refer to the calls made to Hitler by the British Prime Minister, Neville Chamberlain, and the fact of their being disconnected makes an obvious comment. Dali wrote in *The Secret Life*, '"The Enigma of Hitler" . . . constituted a condensed reportage of a series of dreams obviously occasioned by the events of Munich. This picture appeared to me to be charged with prophetic value, as announcing the medieval period which was going to spread its shadow over Europe. Chamberlain's umbrella appeared in this painting in a sinister aspect, identified with a bat and affected me as extremely anguishing at the very time I was painting it.' Like the civil war pictures the telephone scenes are rich, complex and mysterious in their imagery. The lake in 'Mountain lake' in particular is a triple, not just double, paranoiac image – a lake, a fish on a table and, unmistakably, a giant phallus.

In the summer of 1940 Dali and Gala left Europe for the United States where they joined the many other European artists in exile. They were not to return until 1948. There seems to have been a slight hiatus in Dali's output of paintings during the war-time period but in all other respects he enjoyed great success, sharing with Miró a joint retrospective exhibition at the Museum of Modern Art, New York, in 1941, publishing his biography in 1942 and his first novel *Hidden Faces* in 1944. In the same year he painted 'Dream caused by the flight of a bee around a pomegranate one second before awakening' (cat. 200), the herald and first masterpiece of his post-war style. With it can be associated 'The temptation of St Anthony' of 1946 (cat. 199). These paintings are lighter, tighter and glossier than the last pre-war works, more purely fantastic, more illusionistic and in particular display a hyper-realism that looks forward to developments in painting more than two decades later. In their extreme hallucinatory intensity they mark a new extension of Dali's ability to conjure up images from the unconscious; the leaping tigers and long legged elephants of these two pictures are among the great unforgettable images of our time.

A resurgence of the sexual themes of 1929 occurs in another of Dali's post-war

masterpieces 'Young virgin auto-sodomised by her own chastity' (illustration xvii). A related work is 'Young goddess leaning' (cat. 212).

At the same time Dali became more and more interested in Christian devotional subjects and produced a number of personal reworkings of traditional themes, among them 'The Madonna of Port Lligat' (cat. 213) of 1949, the 'Crucifixion' or 'Corpus hypercubicus' (cat. 216) of 1954 and in the same year a second crucifixion 'The Christ of St John of the cross' (cat. 215). This, another of Dali's unforgettable masterpieces, is a highly original reworking and reformulation of one of the central themes of western art. It was inspired by a strange drawing of Christ on the cross (illustration xxix) supposed to have been done by the sixteenth century Saint John of the cross (1542–91). As with the 'Metamorphosis of Narcissus' (cat. 156) our knowledge of the source brings a vivid awareness of Dali's capacity for great dynamic leaps of the imagination.

In the nineteen-sixties Dali became particularly concerned with *recherches visuelles* – explorations of the optical mechanisms of illusion and the perception of images. One line of research was in the construction, using systems of dots, of works with hidden images such as 'Portrait of my dead brother' of 1963 (cat. 218). (All his life Dali was conscious of the brother, also called Salvador, who had died nine months before his own birth.) Another, much more significant, was in the use of stereoscopy and in recent years Dali has produced a sequence of stereoscopic paintings (cats. 235–6, 238–40, 246–7) in which he carries to its ultimate point so far, and with dazzling virtuosity, his aim 'TO MATERIALISE THE IMAGES OF CONCRETE IRRATIONALITY WITH THE MOST IMPERIALIST FURY OF PRECISION.'

*NOTES*

[1] New York 1968.
[2] Quoted in *Dali*, catalogue of retrospective exhibition, Paris, Centre Georges Pompidou, December 1979–April 1980, vol.2, p.71.
[3] *Manifeste du Surréalisme* Paris 1924. All quotations present writer's translation.
[4] *L'Ane Pourri* article by Dali in *Le Surréalisme au Service de la Révolution* issue no.1 July 1930.
[5] Rubin op.cit. p.217.
[6] Rubin op.cit. p.216.
[7] *The Secret Life of Salvador Dali*. English translation New York, Dial Press 1942.
[8] *Conquest of the Irrational*. English translation published as appendix to *The Secret Life of Salvador Dali*, op.cit.
[9] First lines of a poem to Picasso published in *Conquest of the Irrational* op.cit.
[10] *The Secret Life* op.cit.
[11] Maurice Nadeau *Histoire du Surréalisme* Paris 1945. English edition London 1978 (Penguin Books).
[12] Published in *Surrealism* by J. Levy, New York 1936.
[13] Manuscript lost in 1939. Later found and published Paris 1963.
[14] *The Secret Life* op.cit.

# Catalogue

Measurements are given in centimetres,
height before width.

[23]

87 **Gala and the Angelus of Millet before the imminent arrival of the conical anamorphoses** 1933
Oil on panel, 24 × 18.8
*National Gallery of Canada, Ottawa*

88 **Studies for motion picture scenario** 1935
Pencil on paper, 55 × 41
*Perls Galleries, New York*

89 **Gangsterism and goofy visions of New York** 1935
Pencil on paper, 54.6 × 40
*Menil Foundation, Houston*

90 **How super-realist Dali saw Broadway** 1935
Pencil on paper, 48 × 39
*Perls Galleries, New York*

91 **Surrealist mystery of New York** 1935
Oil on canvas, 40 × 30
*Galerie Le Pont, Monte Carlo*

92 **New York?** 1938
Indian ink on paper, 8 × 16
*Private collection*

93 **Daybreak, midday, sunset, evening** 1979
Oil on canvas, 122 × 244
*Private collection*
(accompanied by spoken text)

94 **A watch placed in a suitable place bringing about the death and revival of a young ephebe through an excess of satisfaction**
Oil on board, 122.5 × 244.5
*Private collection*

95 **Nostalgia of the cannibal** 1932
Oil on canvas, 47.2 × 47.2
*Kunstmuseum Hannover mit Sammlung Sprengel*

96 **Partial hallucination: six apparitions of Lenin on a piano** 1931
Oil on canvas, 114 × 146
*Musée National d'Art Moderne – Centre Georges Pompidou, Paris*

97 **Moment of transition** 1934
Oil on canvas, 54 × 65
*Private collection*

98 **The phantom waggon** 1933
Oil on wood, 19 × 24.1
*E. F. W. James West Dean*

99 **Paranoiac-astral image** 1935
Oil on wood, 16 × 21.8
*Wadsworth Atheneum, Hartford, Connecticut*
*(The Ella Gallup Sumner and Mary Catlin Sumner Collection)*

100 **Mediumnistic-paranoiac image** 1935
Oil on wood, 16 × 21.8
*E. F. W. James on loan to the Boymans-van Beuningen Museum, Rotterdam*

101 **Solitude paranoique critique** 1935
Oil on wood, 19 × 23
*Edward James Foundation on loan to the Boymans-van Beuningen Museum, Rotterdam*

102 **The solar table** 1936
Oil on wood, 60 × 46
*Boymans-van Beuningen Museum, Rotterdam*

103 **Geological justice** 1936
Oil on wood, 11 × 19
*E. F. W. James on loan to the Boymans-van Beuningen Museum, Rotterdam*

104 **Forgotten horizon** 1936
Oil on wood, 22 × 26.5
*Tate Gallery, London*

105 **Apparitions of my cousin Carolinetta on the beach at Rosas** 1934
Oil on canvas, 73 × 100
*Private collection*

106 **Couple with heads full of clouds**
Oil on wood, man 92.5 × 62.5
woman 82.5 × 62.5
*Boymans-van Beuningen Museum, Rotterdam*

107 **Study for the woman in 'Couple with heads full of clouds'** 1936
Pencil on paper, 59 × 48
*Edward James Foundation, West Dean*

108 **Don Quixote**
Ink on paper, 45 × 56
*Prince J. L. de Faucigny-Lucinge*

109 **Horsemen** 1934
Ink on paper, 35 × 40
*Prince J. L. de Faucigny-Lucinge*

110 **The cavalier of death** 1934
Ink on paper, 98.4 × 72
*Museum of Modern Art, New York*
*(Gift of Ann C. Resor)*

111 **Variant of the 'Cavalier of death'** 1933
Indian ink on paper, 52 × 37
*François Petit*

112 **Grasshopper child** 1933
Engraving on paper, 37 × 30
*François Petit*

197 **Portrait of the Lady Louis Mountbatten** 1940
Oil on canvas, 65.5 × 54.5
*Private collection*

197a **Portrait of Sir Laurence Olivier as Richard III** 1935
Oil on canvas, 73.7 × 63
*Private collection*

198 **My wife, nude, contemplating her own flesh becoming
stairs, three vertebrae of a column sky and
architecture** 1945
Oil on wood, 61 × 52
*Mr and Mrs Enrique Corcuera*

199 **The temptation of Saint Anthony** 1946
Oil on canvas, 89.7 × 119.5
*Musées Royaux des Beaux Arts de Belgiques, Brussels*

199a **Chariot of Bacchus** 1953
Watercolour on paper, 77 × 101.3
*Private collection*

200 **Dream caused by the flight of a bee around a pomegranate
one second before waking up** 1944
Oil on canvas, 51 × 41
*Thyssen-Bornemisza Collection, Lugano*

201 **Intra-atomic equilibrium of a swan's feather** 1947
Oil on canvas, 77.5 × 96.5
*Private collection*

202 **Molecular equestrian figure** 1952
Indian ink and water colour on paper, 76 × 101.5
*Private collection*

203 **Portrait of Gala with rhinocerontic symptoms** 1954
Oil on canvas, 39 × 31.5
*Private collection*

204 **Exploded Raphaelesque head** 1951
Oil on canvas, 44.5 × 35
*Private collection*

205 **Corpuscular madonna** 1952
Pencil, sepia and indian ink on paper, 55.6 × 43.2
*Museum of Art, Birmingham U.S.A.*
*(Gift of Mr and Mrs C. W. Ireland)*

206 **St Cecilia the ascensionist** 1955
Oil on canvas, 81 × 66
*Private collection*

207 **The Good Shepherd** 1958
Indian ink on paper, 77 × 101.5
*Private collection*

208 **Pope John XXIII** 1958
Indian ink on paper, 54 × 37.5
*Private collection*

209 **The ear of the Pope** 1958
Indian ink on paper, 41 × 33
*Private collection*

210 **Angel** *c.*1957–8
Indian ink on paper, 44.5 × 28.5
*Private collection*

211 **The servant of the disciples of Emmaus** 1960
Oil on canvas, 25 × 22.5
*Private collection*

212 **Young goddess leaning** 1960
Oil on canvas, 92.5 × 153
*Private collection*

213 **First study for the 'Madonna of Port Lligat'** 1949
Oil on canvas, 48.9 × 37.5
*Marquette University Committee on the Fine Arts*

214 **Study for 'Christ on the Cross'** 1951
Pencil and gouache, 73 × 96
*Claude Volnay, Paris*

215 **Christ of St John of the cross** 1951
Oil on canvas, 205 × 116
*Glasgow Art Gallery*

216 **Crucifixion or Corpus hypercubicus** 1954
Oil on canvas, 194.5 × 124
*Metropolitan Museum of Art, New York*
*(Gift of the Chester Dale Collection)*

217 **The Sistine madonna** 1958
Oil on canvas, 223 × 190
*Mrs H. J. Heinz*

218 **Portrait of my dead brother** 1963
Oil on canvas, 190 × 190
*Private collection*

219 **Costumes for 'Bacchanal'**
Gouache on paper, 55 × 76
*Private collection*

220 **Drawings for 'Le Labyrinthe' (The Maze), 'La Limite' and
other books by Maurice Sandoz**
*Private collection, Brazil*

221 **The judgement of Paris** 1950
Ink on paper, 62.2 × 76.5
*Countess Guerini-Maraldi, New York*

222 **Hermaphrodite** 1952
Pencil on paper, 55.5 × 43
*Countess Guerini-Maraldi, New York*

223 **Allegory** 1958
Watercolour on paper, 63.5 × 58.5
*Private collection*

224 Medusa's head 1962
Watercolour on paper, 77 × 101.5
*Private collection*

225 Suspended church 1959
Charcoal on paper, 32.5 × 25.5
*Private collection*

226 Suspended church 1959
Charcoal, pen, ink and pencil on paper, 76 × 102
*Private collection*

227 Suspended church 1959
Charcoal on paper, 35.5 × 27
*Private collection*

228 Creation of the Milky Way 1970
Watercolour on paper, 97 × 58.5
*Private collection*

229 Landscape at Empurda 1970
Oil on copper, 39 × 49
*Private collection*

230 Nude in a landscape 1975
Pencil on paper, 36.5 × 25.5
*Private collection*

231 Landscape at Empurda 1976
Indian ink on paper, 75 × 100
*Private collection*

232 Bridge and horseman
Indian ink on paper, 75 × 100
*Private collection*

233 Horseman and church
Indian ink and paper, 75 × 100
*Private collection*

234 Architectural project 1976
Gouache and ink on newspaper, 29.5 × 18.5
*Private collection*

235 Battle in the clouds 1974
Stereoscopic painting in two sections
Oil on canvas, each 100 × 100
*Private collection*

236 The chair 1975
Stereoscopic painting in two sections
Oil on canvas, each 400 × 210
*Private collection*

237 Drawing for the stereoscopic installation of
'The chair' 1976
Biro on paper with collage, 57.5 × 77
*Private collection*

238 Las Meninas
Stereoscopic painting in two sections
Oil on canvas, each 35.6 × 25.1
*Private collection*

239 Dali lifts off the skin from the Mediterranean sea to show
Gala the birth of Venus 1977
Stereoscopic painting in two sections
Oil on canvas, each 101 × 101
*Private collection*

240 Dali's hand raising a gold veil in the shape of a cloud to
show Gala the naked dawn, far beyond the sun (Homage
to Claude Lorrain) 1977
Stereoscopic painting in two sections
Oil on canvas, each 60 × 60
*Private collection*

241 Portrait of Gala looking onto the Mediterranean Sea
which from a distance of 20 metres is transformed into a
portrait of Abraham Lincoln (Homage to Rothko)
Oil on canvas, 244 × 183
*Martin Lawrence Limited Editions, Van Nuys, California*

242 Cybernetic Odalisque 1978
Oil on canvas, 200 × 200
*Private collection*

243 Pierrot Lunaire 1978
Unfinished
Oil on canvas, 111 × 244
*Private collection*

244 Harmony of the spheres 1978
Oil on canvas, 100 × 100
*Private collection*

245 Towards research into the fourth dimension 1979
Oil on canvas, 246 × 122.5
*Private collection*

246 Pentagonal sardana 1978–9
Stereoscopic painting in two sections
Oil on canvas, each 100 × 100
*Private collection*

247 The Christ of Gala 1978
Stereoscopic painting in two sections
Oil on canvas, each 100 × 100
*Center Art Gallery, Honolulu*

248 More beautiful than Canova 1979
Oil on copper, 32 × 24
*Private collection*

249 Copy of a Rubens' copy of a Leonardo 1979
Oil on wood, 18 × 24
*Private collection*

250 Phosphene 1979
Oil on canvas, 155 × 110
*Private collection*

251 Raphaelesque hallucination 1979
Oil on plywood, 120 × 244
*Private collection*

# Photographic Credits

A. C. Cooper, London  100, 106, 119, 149, 150, 155, 156
Dasa Editions, S.A.  3, 15, 206, 212, FC194
Robert Descharnes, Paris  28, 29
Editions Draeger, Paris  14, 22
Walter Drayer  FC144
Jacques Faujour, Centre Georges Pompidou, Paris  2, 67, 71,
    FC259
Voorburg Frequin  102
Jacqueline Hyde  53, FC75
Eric Jourdan, Paris  FC111
Studio d'arte pescali  FC130
Eileen Tweedy  122
Photos X, D.R.  77, 82, 126, 143, 153, 198, FC121, FC122,
    FC143

# List of Lenders

Juan Abelló Prat-Mollet 8
Albright-Knox Art Gallery 42, 141
Segialan Anstalt 163

Barcelona, Museo de arte Moderno 9, 10
Galerie Beyeler 54
Birmingham Museum of Art, Alabama 205
Brussels, Musées Royaux des Beaux-Arts de Belgique 199

Joan Casanelles 13
National Gallery of Canada 87
Cavalieri Holding Co. Inc. 153
Chatelard Collection 72
Art Institute of Chicago 134
Mr & Mrs Enrique Corcuera 198

Davlyn Gallery, New York 70, 80

Etude d'Avocat Cortez-Perez Escolar 135

Prince J. L. de Faucigny-Lucinge 71, 108, 109
Fogg Art Museum 137

Monsieur et Madame Gilli 115
Glasgow Art Gallery 215
Countess Guerini-Maraldi 221–2

Hannover Kunstmuseum mit Samlung Sprengel 95
Klaus Hegewish 47
Mrs H. J. Heinz 217
Von der Heydt Museum 79
Honolulu, Center Art Gallery 247

Ikeda Museum of Twentieth-Century Art 18

Edward James Foundation 98, 100, 101, 107, 113, 116, 117,
    119, 128, 129, 131, 132, 133, 136, 138, 139, 148, 155,
    165, 167, 169, 170, 172–5, 177–82, 184, 188, 189,
    194–6

Kresge Art Gallery 65

Félix Labisse 63, 140
Mme René Laporte 61
Martin Lawrence Limited Editions 241
Virginia Lust Gallery 168

Henry P. McIlhenny 192
Madrid, Museo Espanol de Arte Contemporaneo 11, 12
Marquette University Committee on the Fine Arts 213
Menil Foundation 89
Mizne-Blumental Collection 26

Nellens Collection 118
New York, Metropolitan Museum of Art 216
New York, Museum of Modern Art 24, 57, 64, 152, 162, 176

Paris, Musée National d'Art Moderne 27, 96
Paris, Musée Picasso 45, 62
Perls Galleries 58, 69, 75, 81, 83, 85, 86, 88, 90, 125
Petit Collection 28, 36, 37–41, 43–4, 56, 59, 60, 68, 76, 111,
    112, 124, 183, 190, 193
François-Xavier Petit 34
Galerie Le Pont 91
Private Collection 1–3, 5–7, 14, 19–23, 25, 30–1, 35, 38,
    41, 48–50, 52–3, 67, 73–4, 77–8, 82, 92–4, 97, 105,
    121–123, 127, 130, 143–7, 154, 157, 160, 164, 166,
    171, 185–7, 191, 196a, 197, 197a, 199a, 201–4, 206–12,
    218–20, 223–40, 242–5, 248–51

Charles Rattan 114
Rio de Janeiro, Fundaçao Raymundo Ottoni de Castro Maya 32
Rotterdam, Museum Boymans-van Beuningen 102, 106, 149,
    150–2, 155, 159

San Diego Museum of Art 33
Gianna Sistu 55
Gertrude Stein Gallery 51
Stockholm, Moderna Museet 84

Tate Gallery 104, 156, 158, 161
Thyssen-Bornemisza Collection 65, 200

Vercamer Collection 126
Claude Volnay 214

Wadsworth Atheneum 99, 142

# Film sequences

from 'Un Chien Andalou'

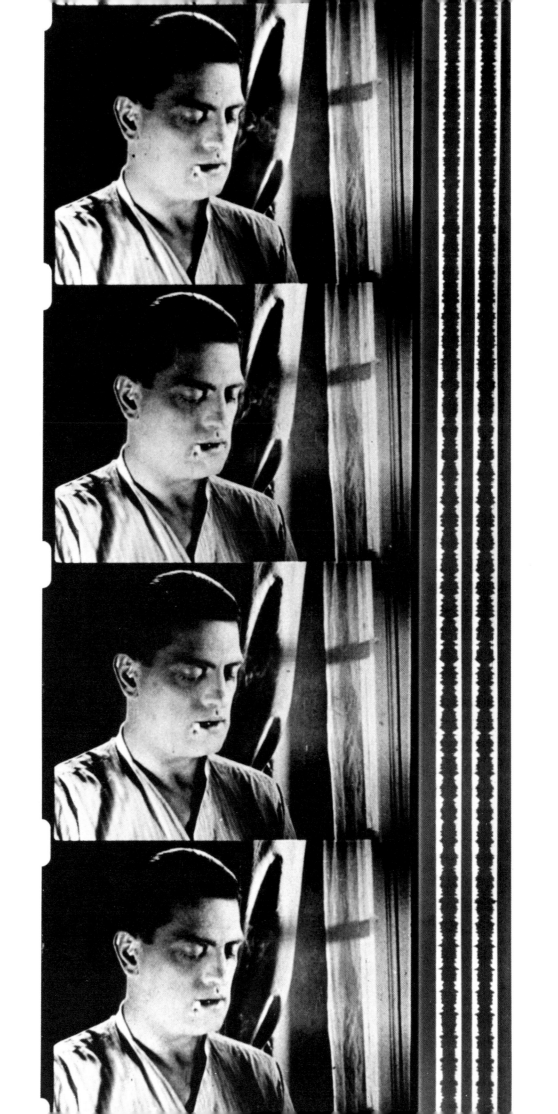

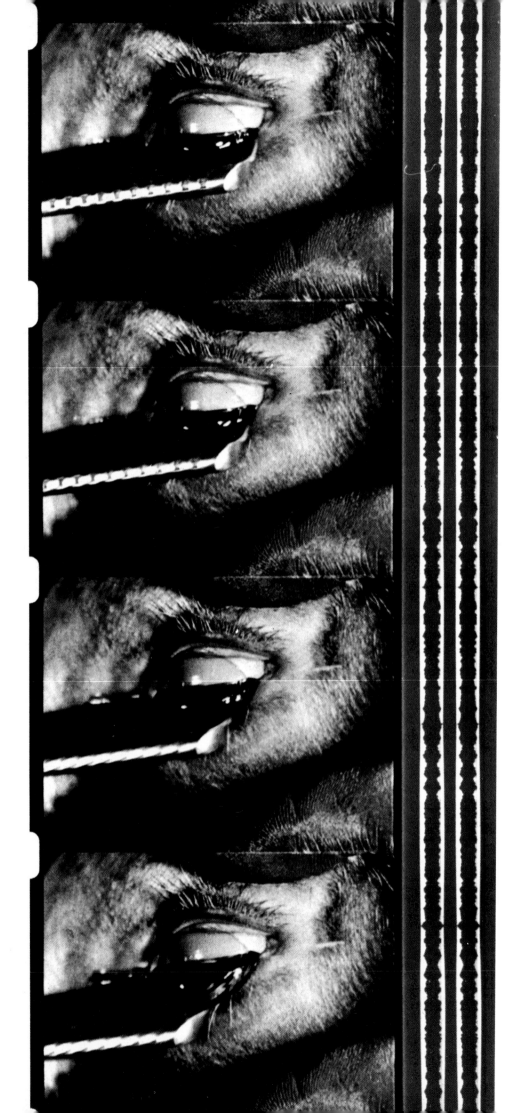

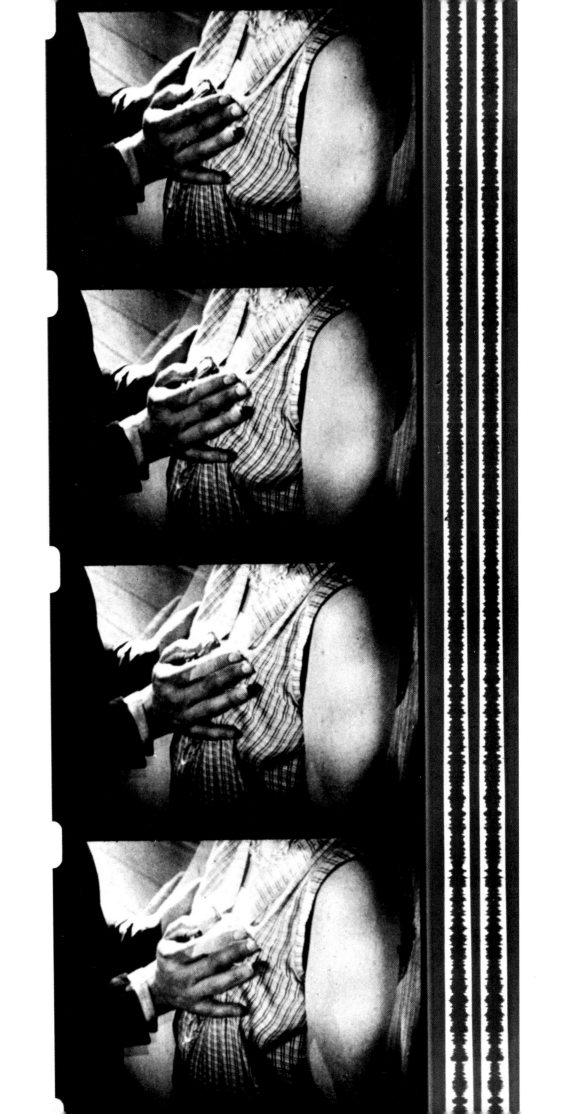

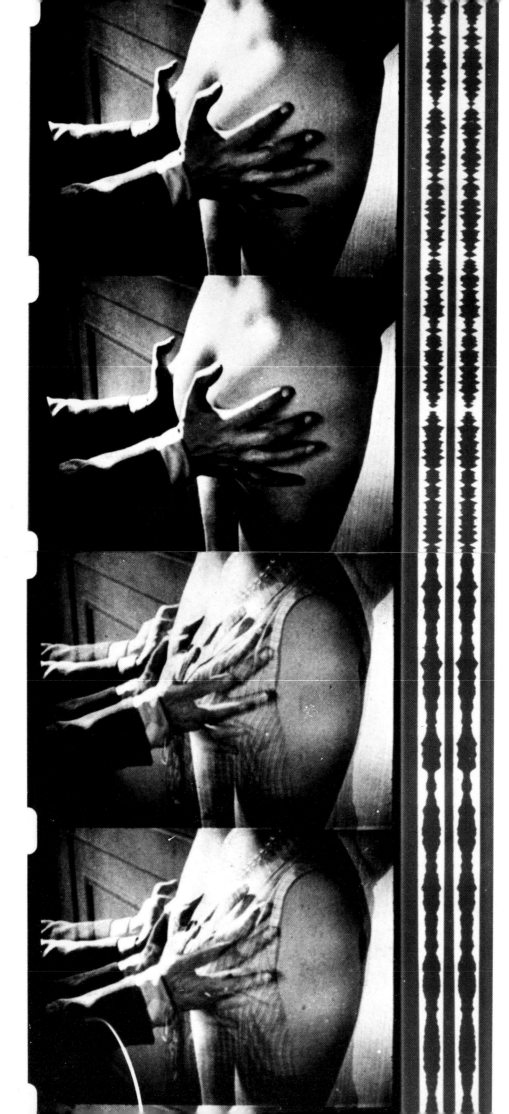

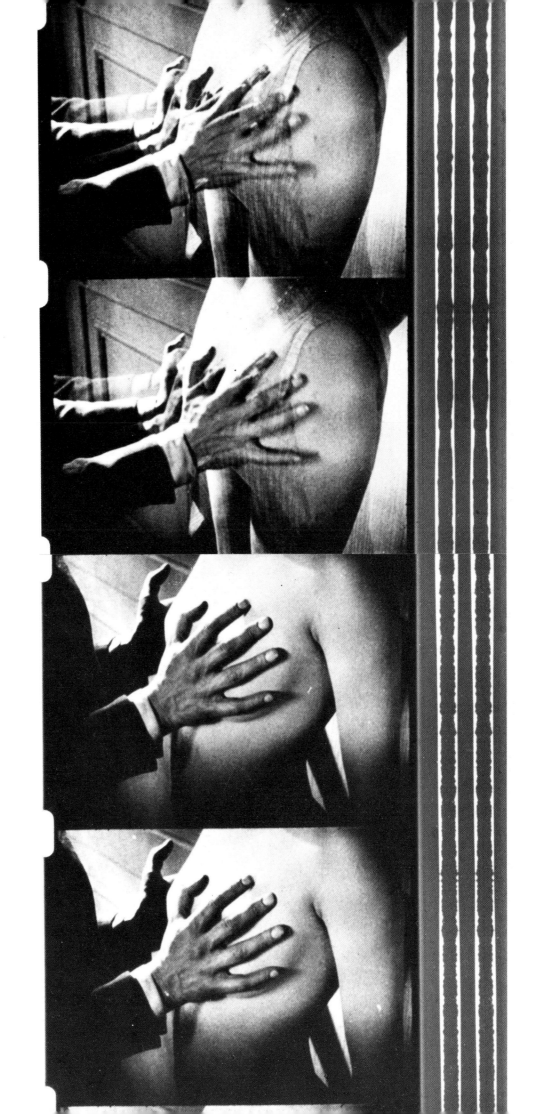

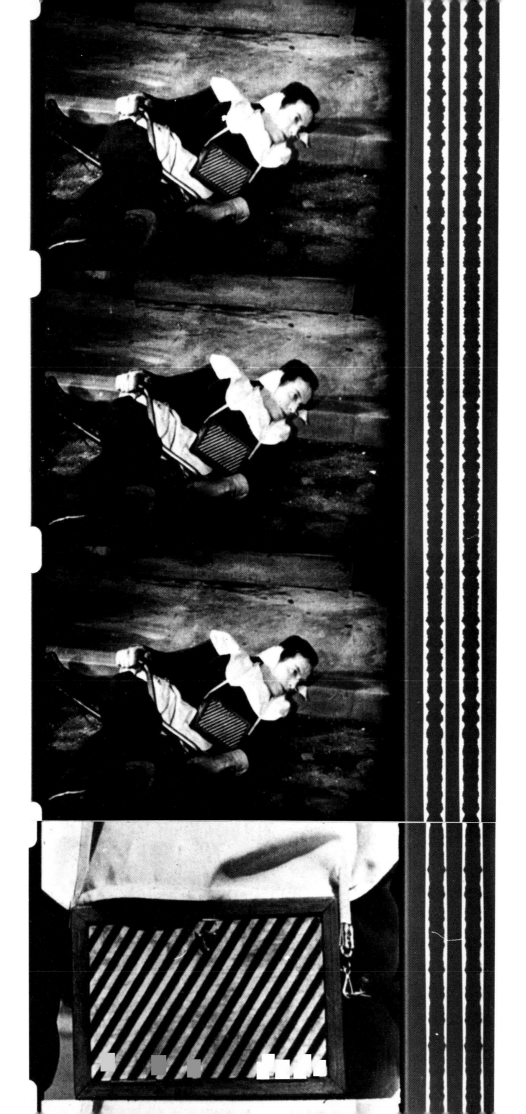

# Illustrations

Captions show catalogue numbers.
Roman numerals are given to works
not exhibited.

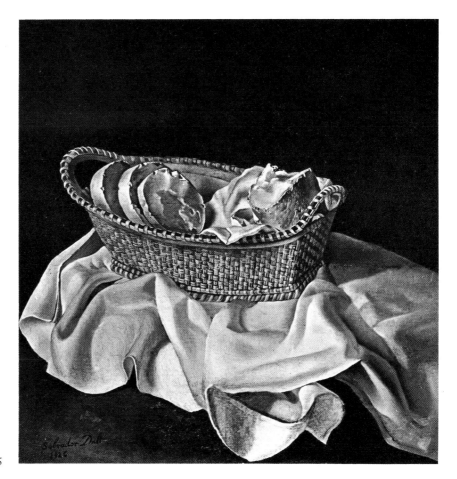

**xxxi  The bread basket**  1926
Oil on panel, 31.5 × 31.5

**3  Salema**  1920
Oil on canvas, 30.5 × 34.6
*Private collection*

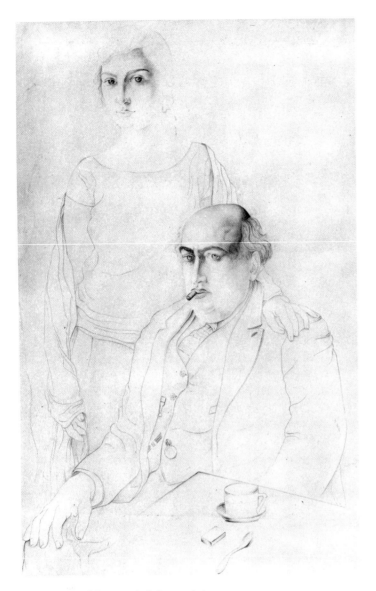

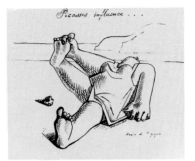

15 **Picasso's influence**
Ink on paper, 14 × 16.5
*Private collection*

10 **Portrait of the artist's father and sister**
1925
Pencil on paper, 49 × 33
*Museo Arte Moderno, Barcelona*

37 **Erotic drawing** 1931
Indian ink and pencil on paper,
28 × 22
*François Petit*

37a **Choice treats for children** 1933
Indian ink and pencil on paper,
27 × 18.3
*François Petit*

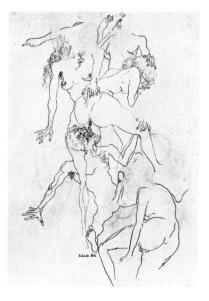

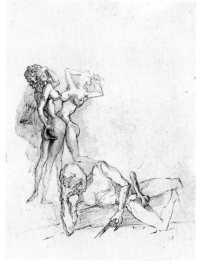

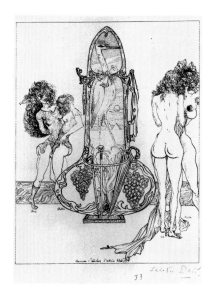

38 **Erotic drawing** 1931
Indian ink and pencil on paper,
21.7 × 21.7
*François Petit*

39 **Erotic drawing** 1931
Indian ink and pencil on paper,
26 × 20
*François Petit*

40 **Order: spoil the entire state** 1933
Ink on paper, 28.2 × 21.3
*François Petit*

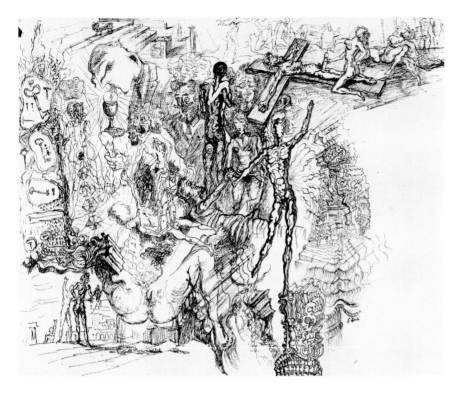

**41 Erotic drawing** 1931
Ink on paper, 18 × 23.5
*François Petit*

*Below left*
**120 Venus de Milo with drawers**
1936–64
Patinated bronze, 98 × 32.5 × 35
*Private collection*

*Below right*
**42 Andromeda** 1930
Ink on paper, 72.5 × 54.5
*Albright-Knox Art Gallery, Buffalo,
New York
(Gift of Conger Goodyear 1940)*

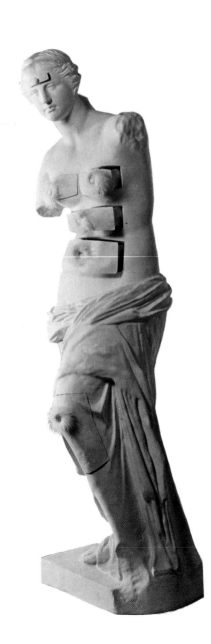

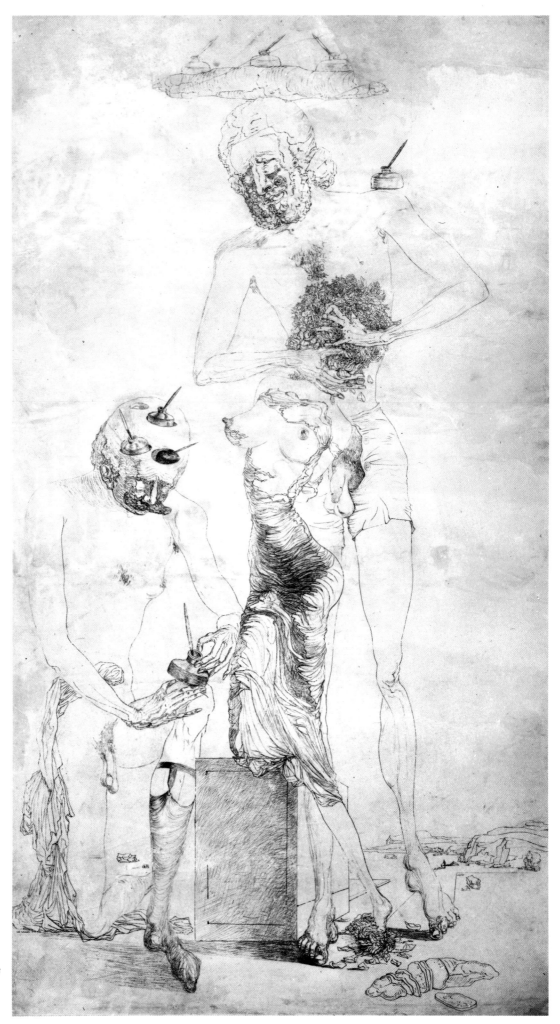

**46 William Tell, Gradiva and the**
**average bureaucrat** 1932
Ink on paper, 118 × 65
*Private collection*

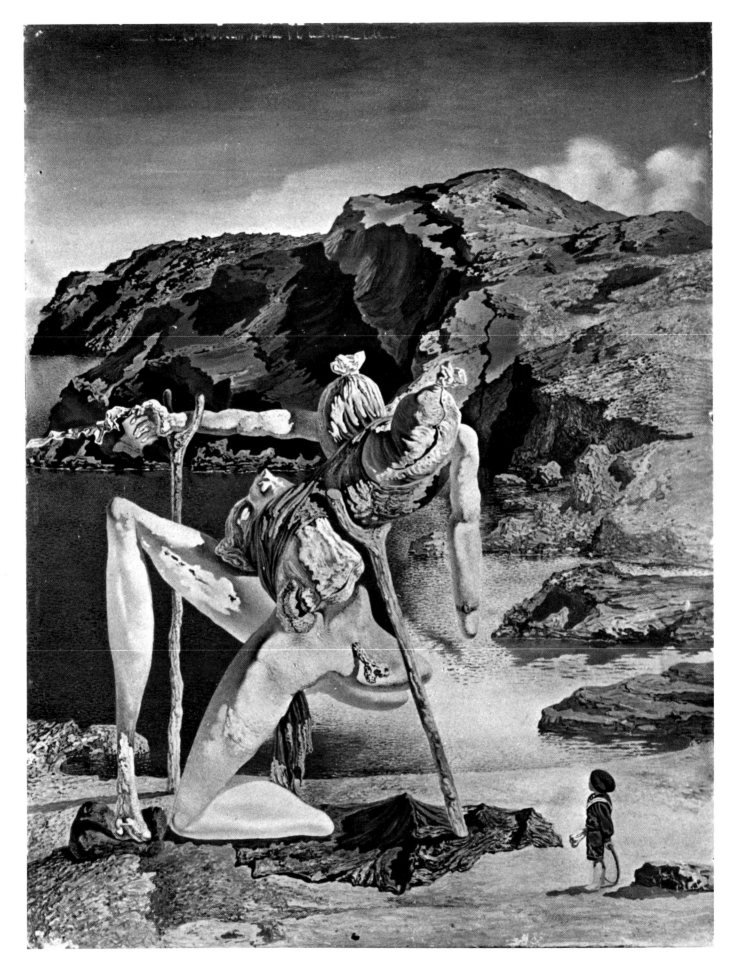

xx  **The ghost of sex appeal**  1934
Oil on canvas, 18 × 14
*Private collection*

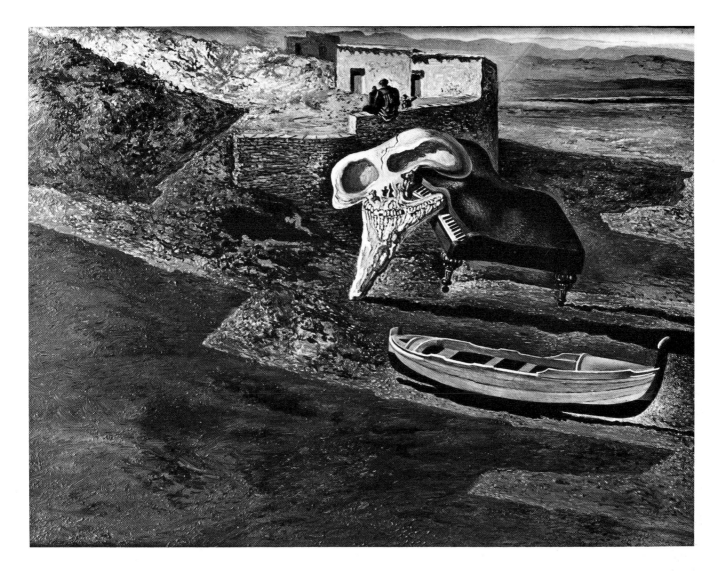

**xxi Atmospheric head of death sodomising a
grand piano** 1934
Oil on canvas, 23 × 32

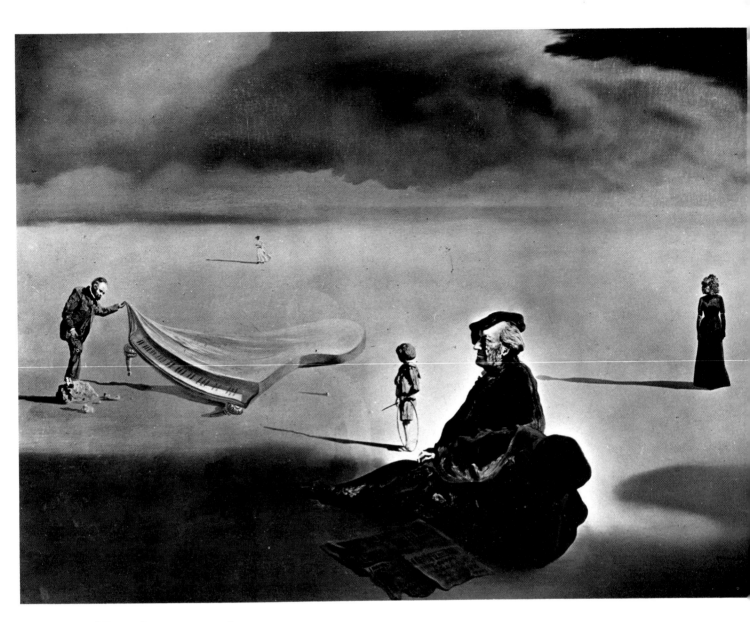

**xxii  A chemist lifting with extreme precaution
the lid of a grand piano**  1936
Oil on canvas, 48 × 62

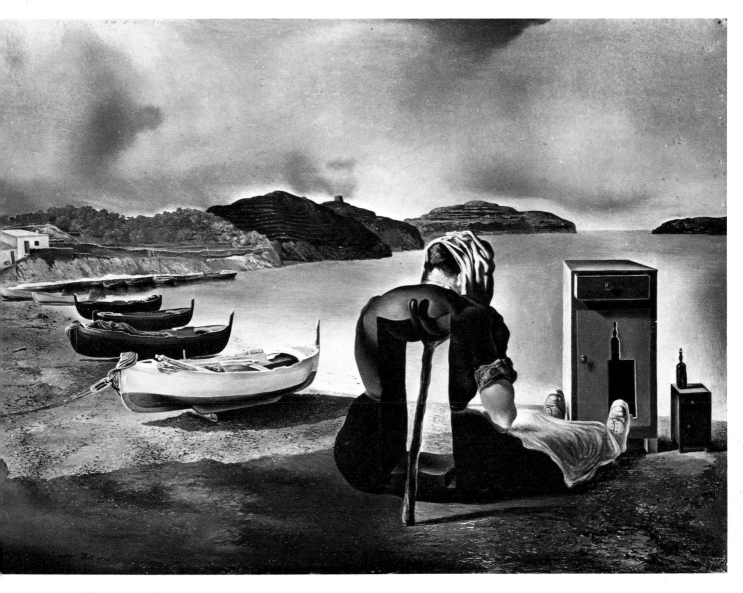

xiv **Separation of furniture – aliment** 1934
Oil on panel, 24 × 19

**126  The phenomenon of ecstasy**  1933
Collage on paper, 27 × 18.5
*Madame Vercamer, Paris*

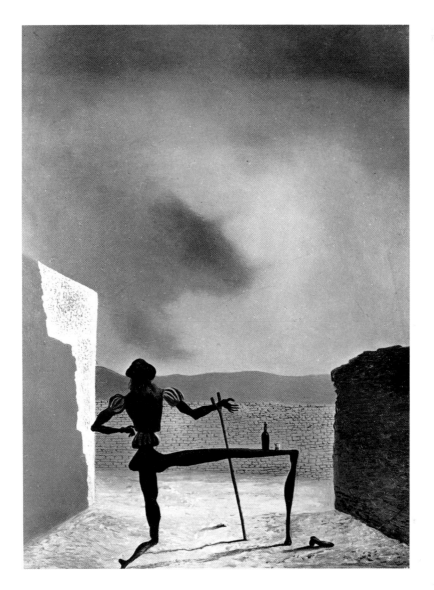

**xxiii The ghost of Vermeer of Delft
usable as a table** 1934
Oil on panel, 18 × 14

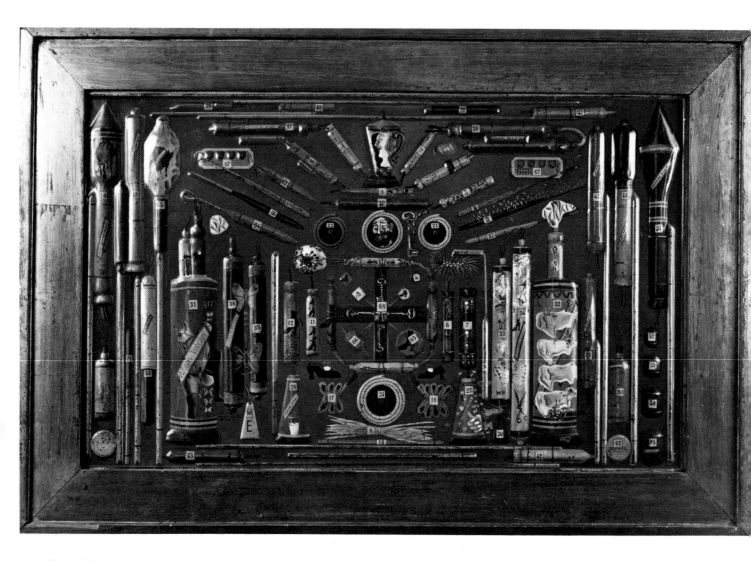

**122 Sheet of demential associations or fireworks** 1930–1
Oil on embossed pewter, 40 × 65
*Private collection*

**32  Mae West lips sofa**  *c.*1936
Woodframe covered with pink satin,
86 × 182 × 80
*E. F. W. James*

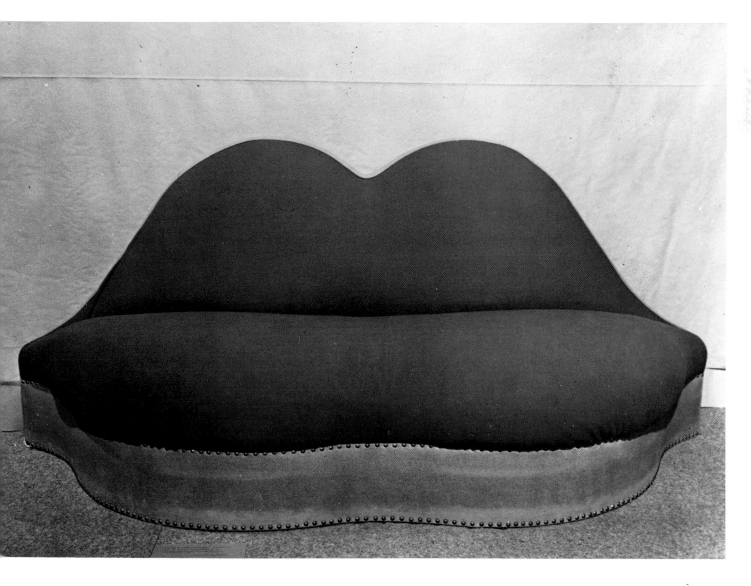

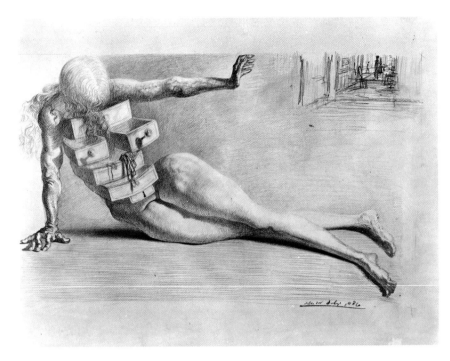

**134 City of drawers** 1936
Pencil on paper, 26.5 × 43.5
*Art Institute of Chicago 1963.3*

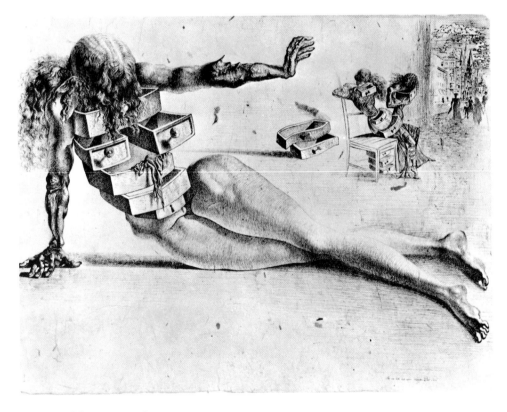

**133 City of drawers** 1936
Indian ink on paper, 32 × 41.5
*Edward James Foundation, West Dean*

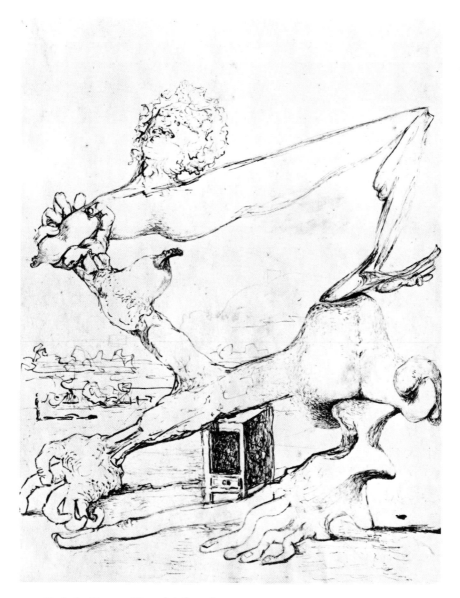

**157**  **Study for 'Premonition of civil war'**  1934
Charcoal on paper, 105 × 80
*Private collection*

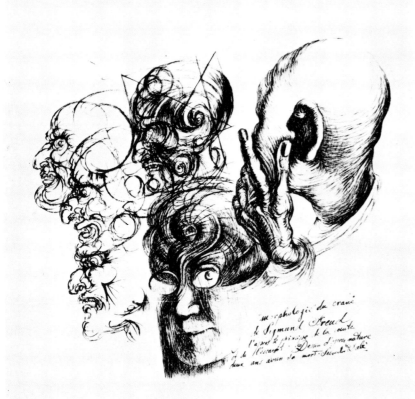

xxv **Portrait of Freud** 1938
Ink on paper, 12.5 × 21
*Private collection*

183 **Portrait of Freud** 1938
Indian ink on paper, 27 × 23
*François Petit*

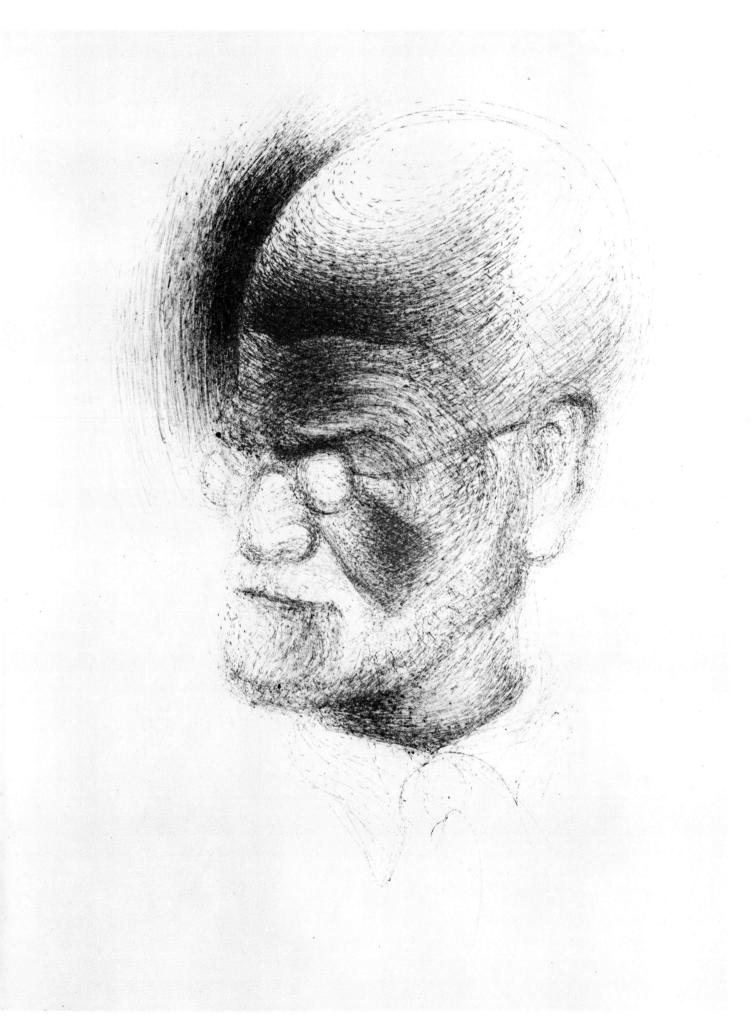

**84 Portrait of Freud** 1938
Ink on paper, 29.5 × 26.5
*Edward James Foundation on loan to the*
*Boymans-van Beuningen Museum, Rotterdam*

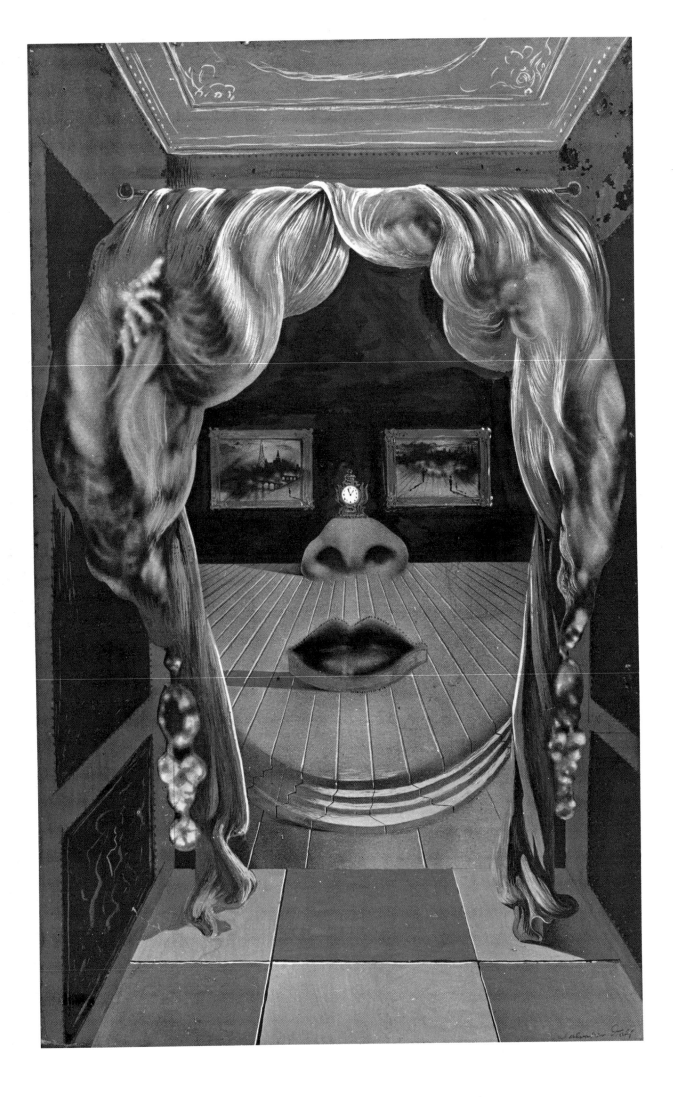

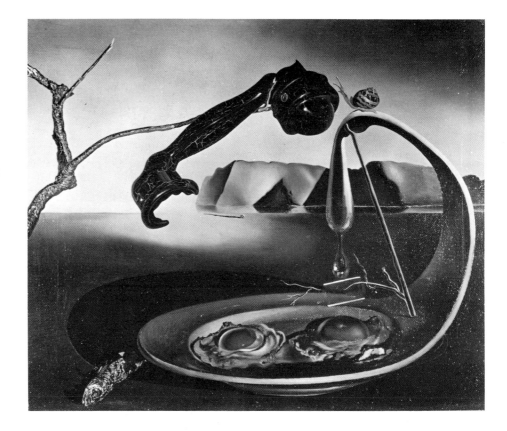

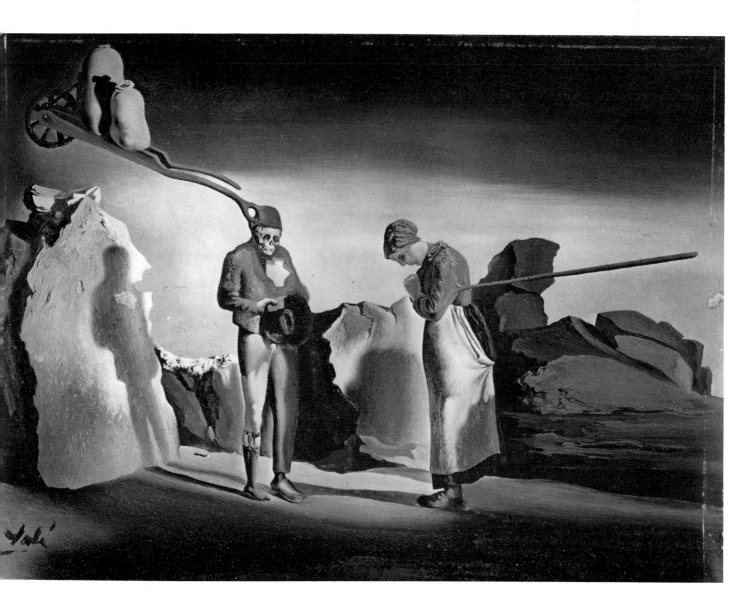

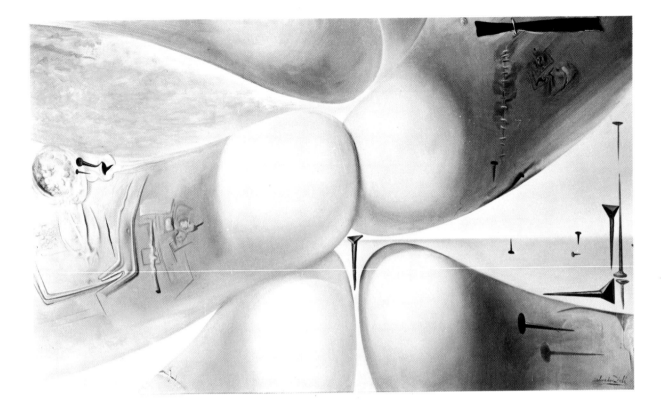

**212 Young goddess leaning** 1960
Oil on canvas, 92.5 × 153
*Private collection*

**11 Girl standing at the window** 1925
Oil on board, 155 × 74.5
*Museo Espanol de Arte Contemporaneo,*
*Madrid*

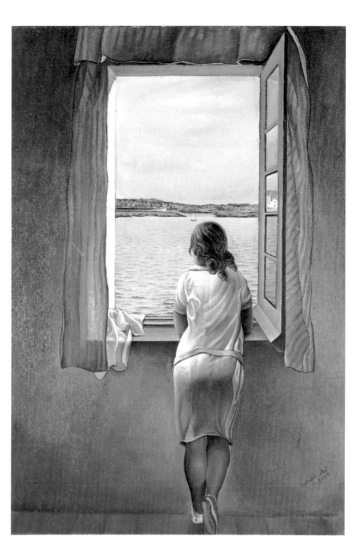

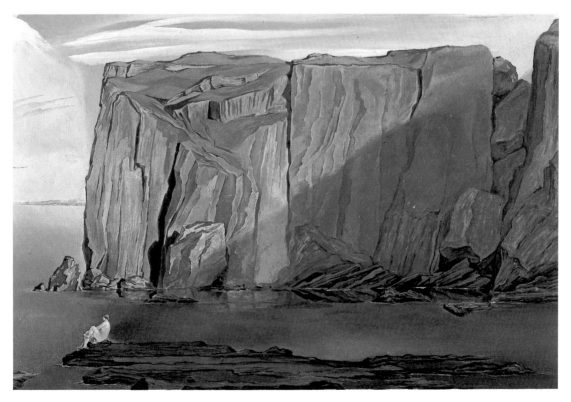

**14 Penya-Segats** 1926
Oil on wood, 26 × 40
*Private collection*

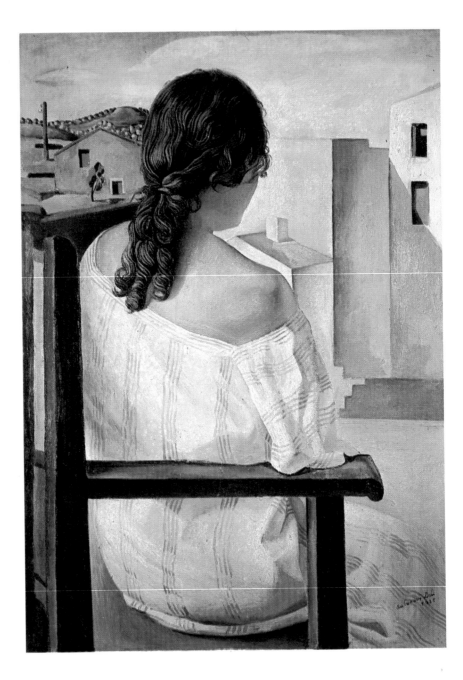

**12  Seated girl seen from the back**  1925
Oil on canvas, 103 × 75
*Museo Espanol de Arte Contemporaneo,*
*Madrid*

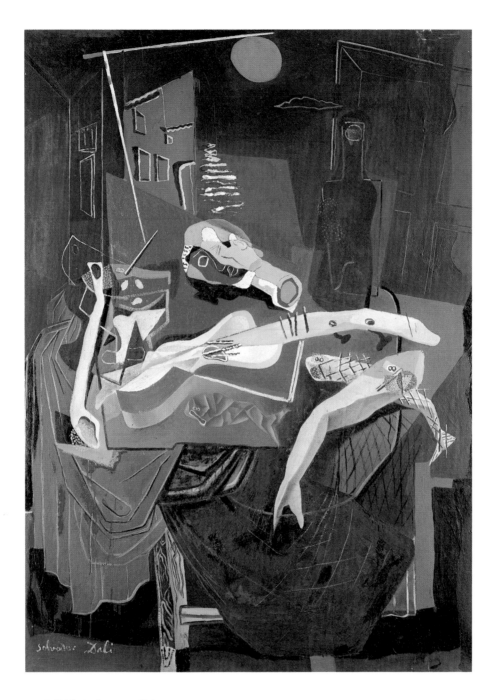

**22  Still life in the moonlight**  1927
Oil on canvas, 199 × 150
*Private collection*

**26 The wounded bird** 1926
Oil and sand on cardboard.
55 × 65.5
*Mizne-Blumental collection*

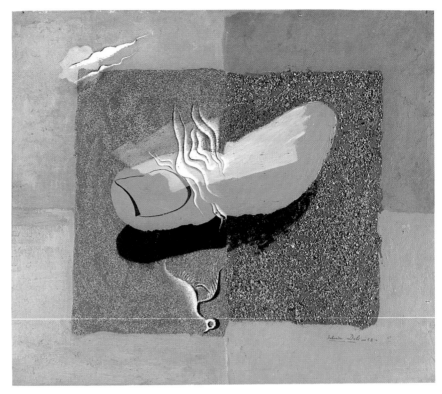

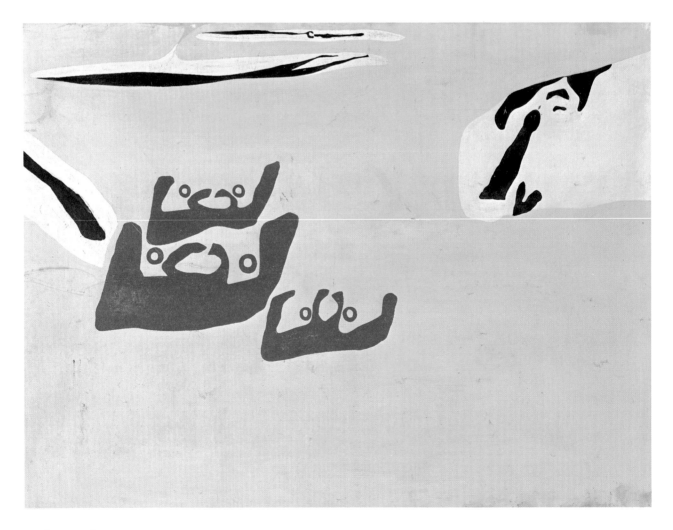

**25 Sun** 1928
Oil on canvas, 147 × 196
*Private collection*

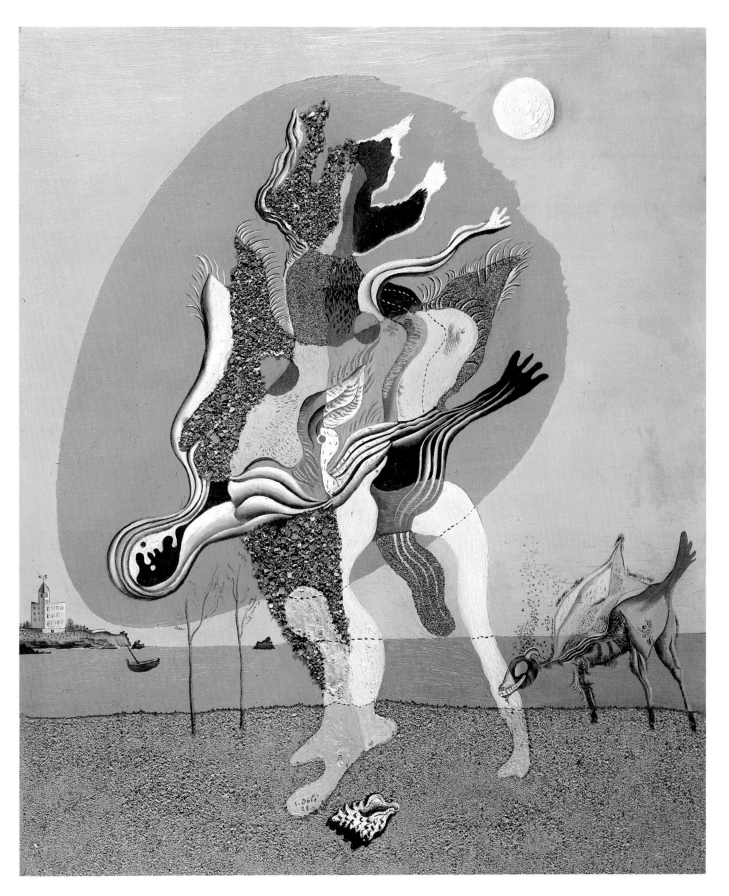

**28 The decayed donkey** 1928
Oil on wood, 61 × 50
*Petit collection*

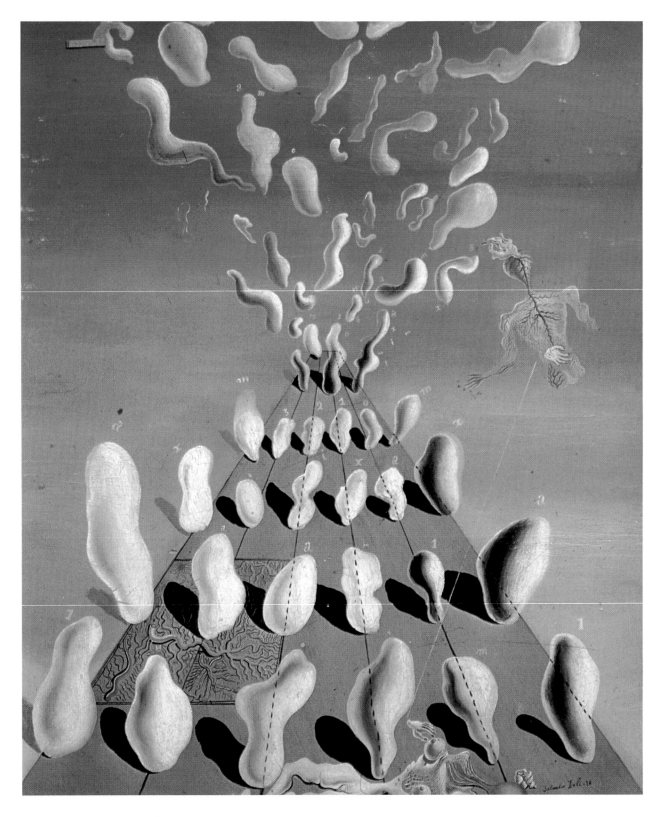

**29 Inaugural goose flesh** 1928
Oil on canvas, 75.5 × 62.5
*Private collection*

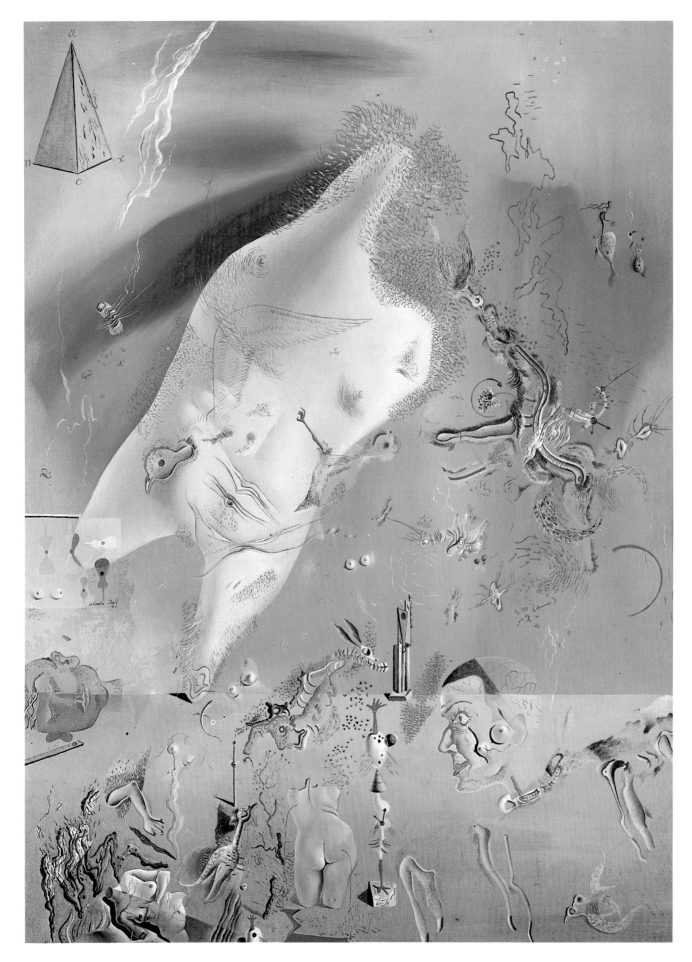

**31 Senility** 1926–7
Oil on wood, 63 × 47
*Private collection*

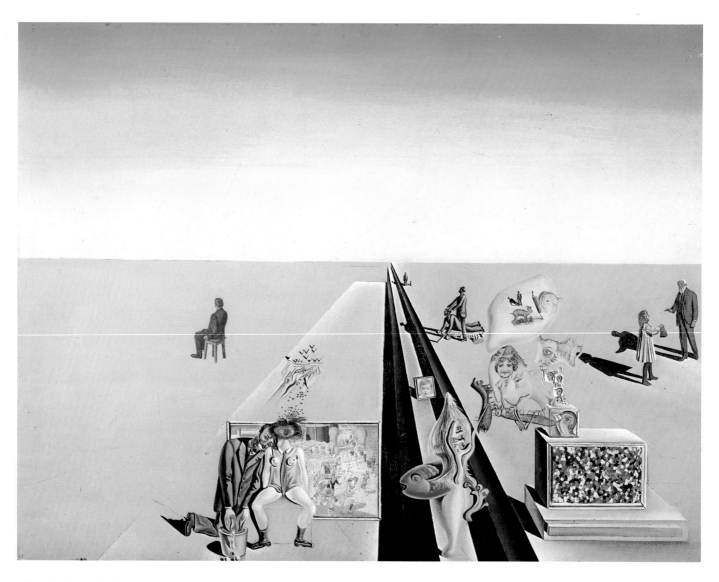

i **The first day of spring** 1929
Oil and collage on board, 49.5 × 64

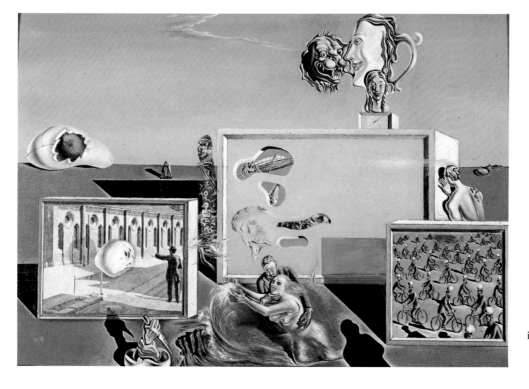

*Left*
ii **Illuminated pleasures** 1929
Oil and collage on board, 24 × 35
*Museum of Modern Art, New York
(The Sidney and Harriet Janis Collection
1957)*

*Opposite*
iv **The lugubrious game** 1929
Oil and collage on canvas, 31 × 41
*Private collection*

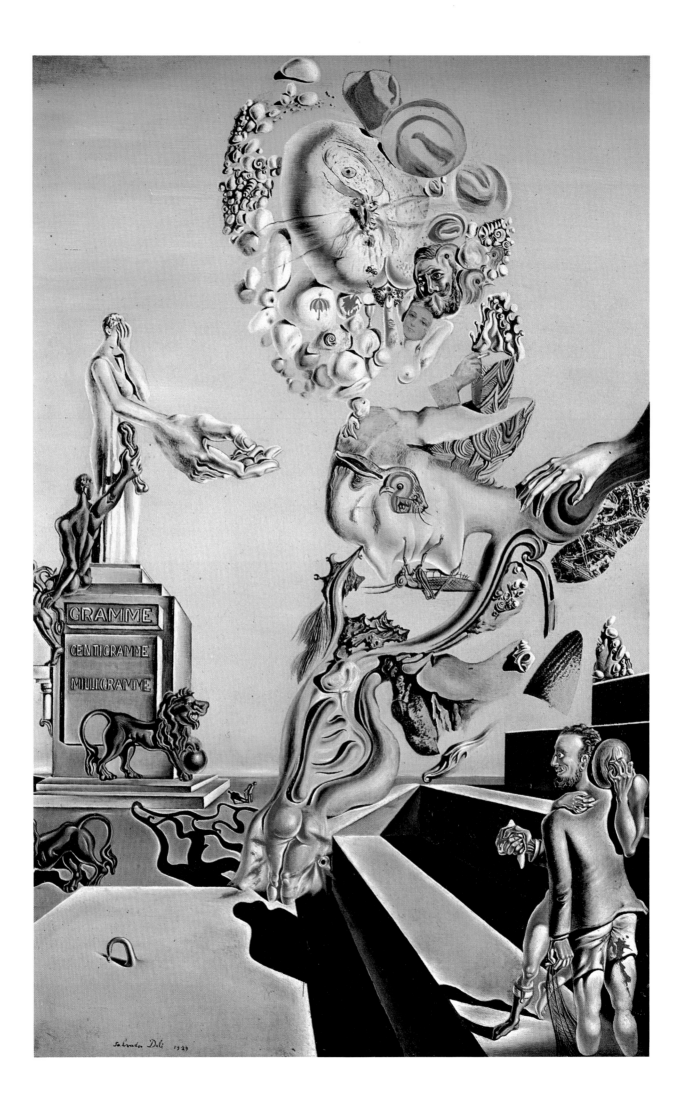

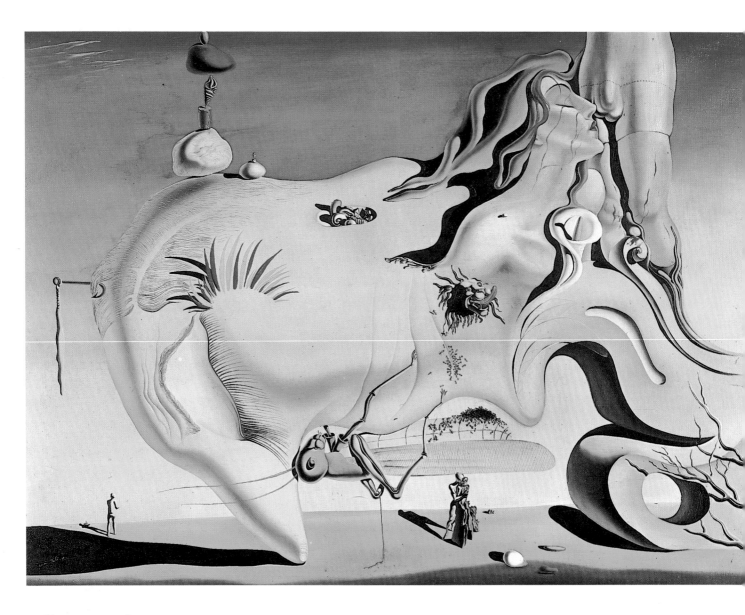

**35** **The great masturbator** 1929
Oil on canvas, 110 × 150
*Private collection*

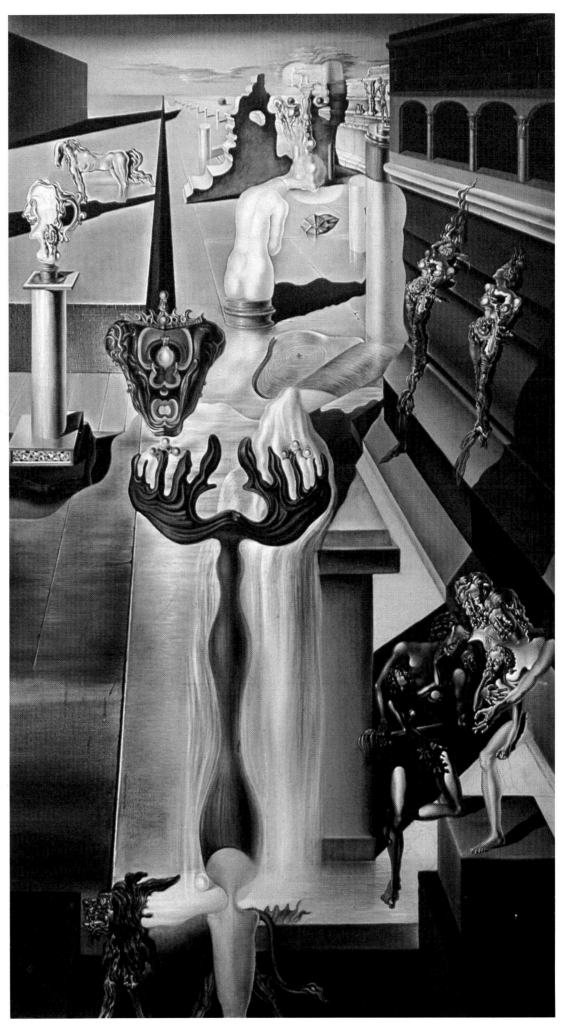

**The invisible man** 1929–33
Oil on canvas, 143 × 81
*Private collection*

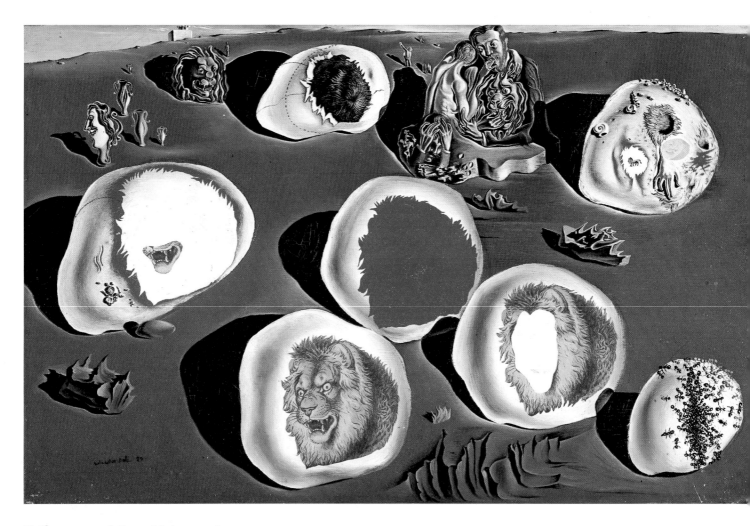

iii  **The accommodations of desires**  1926
   Oil on panel, 22 × 35

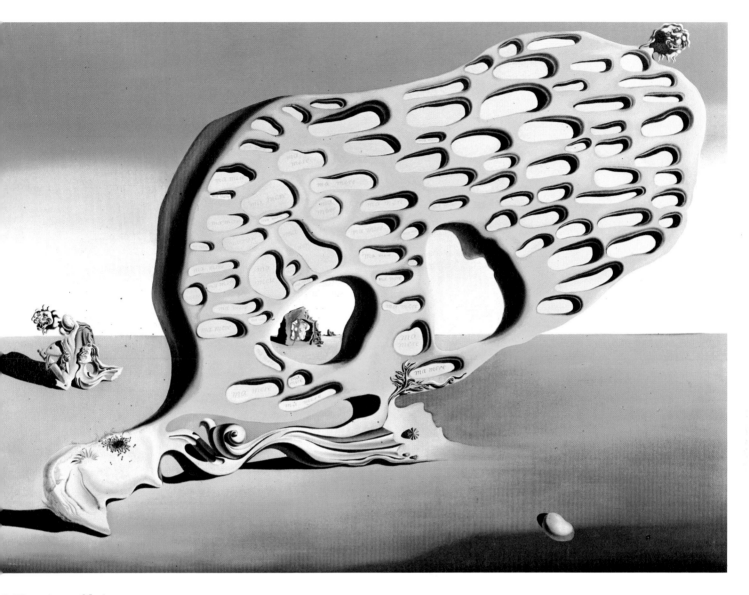

**6 The enigma of desire** 1929
Oil on canvas, 110 × 150.7
*Oskar R. Schlag, Zurich*

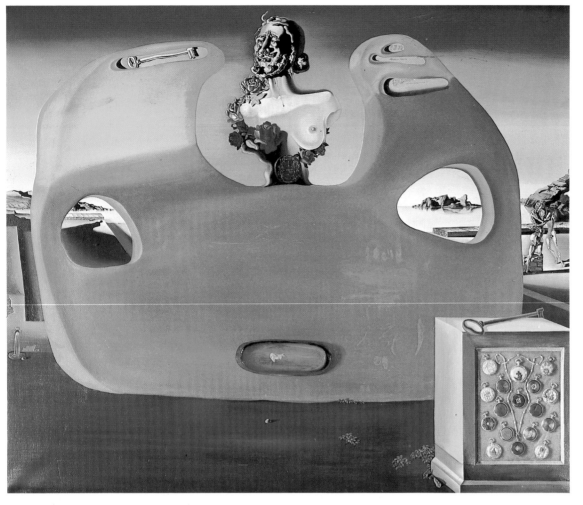

vi  Memory of the
    woman/child 1932

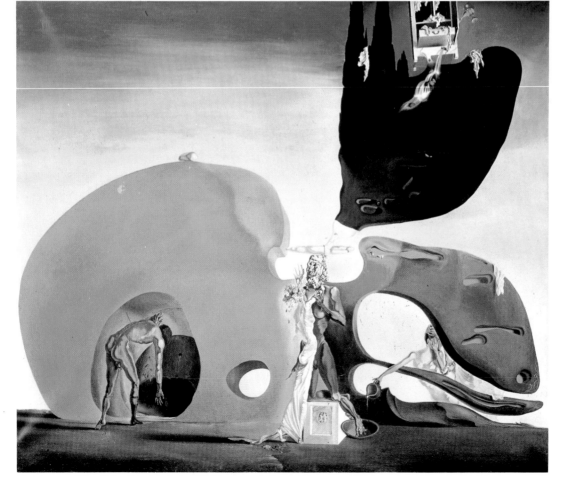

vii  The birth of liquid desires 1932
     Oil on canvas, 122 × 95
     *Peggy Guggenheim Foundation, V*

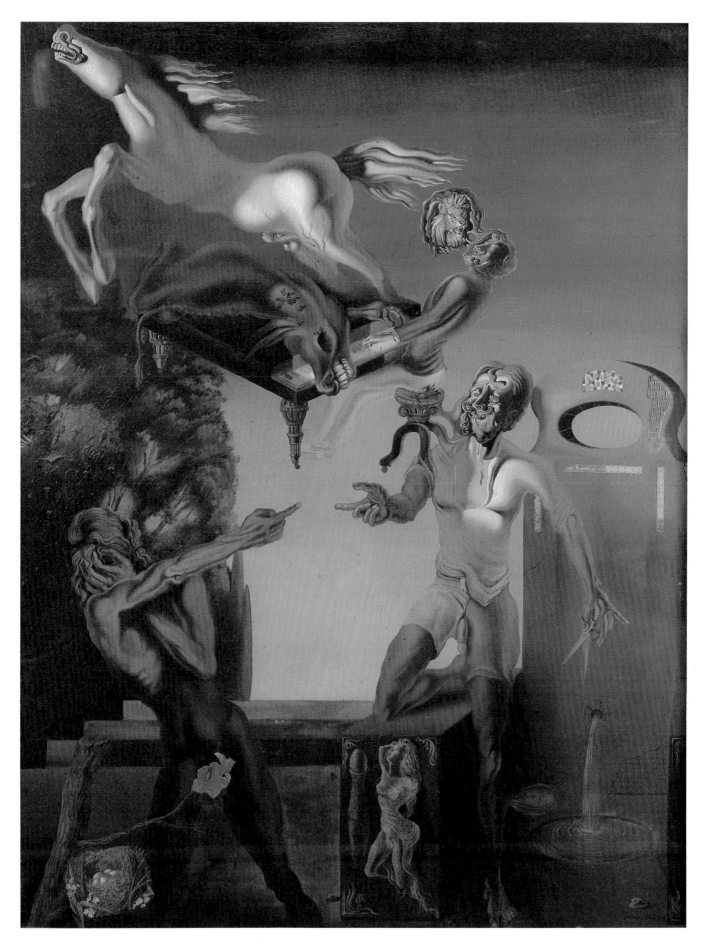

xxx  **William Tell**  1930
Oil and collage on canvas, 113 × 87
*Private collection*

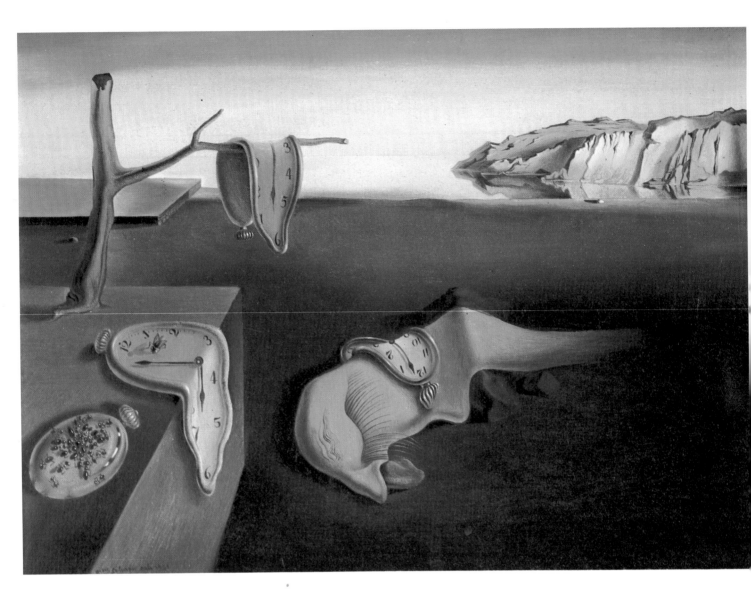

**64 The persistence of memory** 1931
Oil on canvas. 24.1 × 33
*Museum of Modern Art, New York*
*(Anonymous gift 1934)*

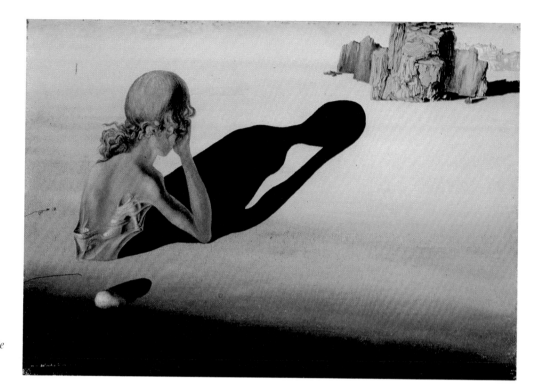

5  **Remorse or Sphinx embedded
   in the sand**  1931
   Oil on canvas, 19.1 × 26.9
   *Kresge Art Gallery, Michigan State
   University*
   *(Gift of John F. Wolfram)*

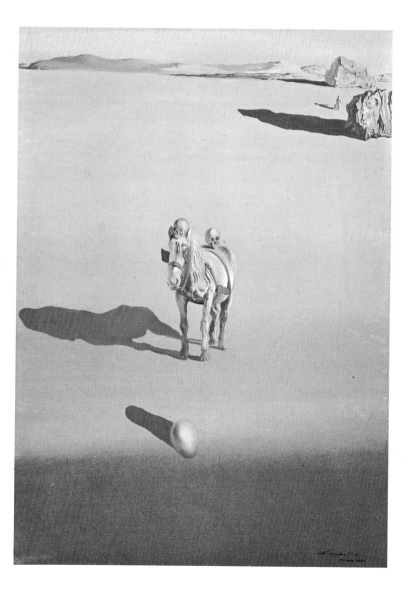

v  **The geological development
   February**  1933
   Oil on canvas

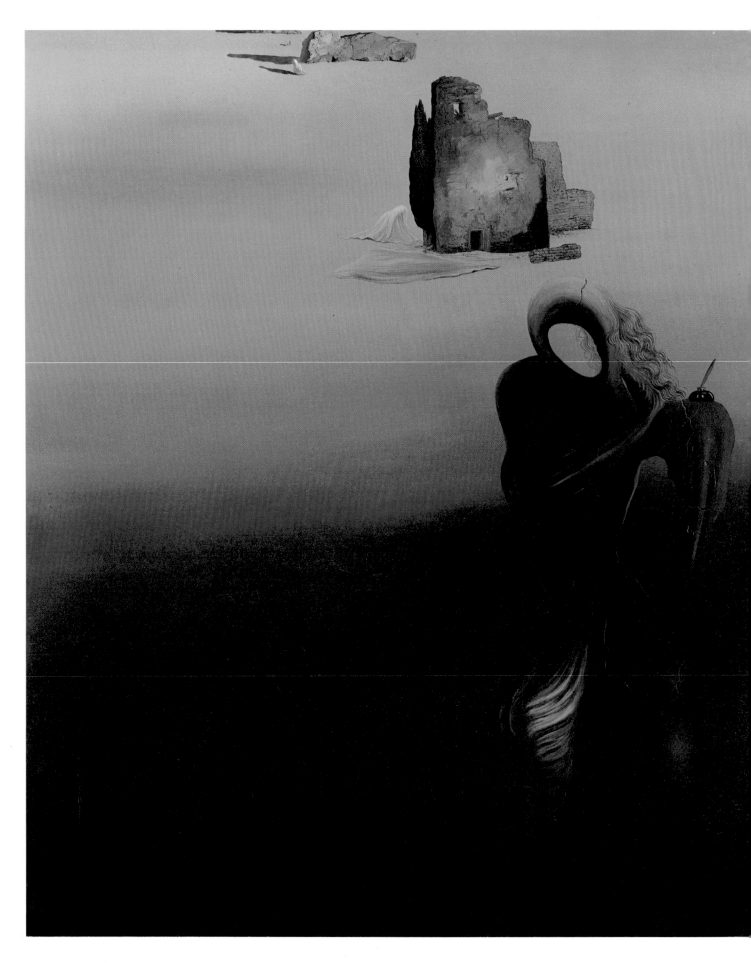

**66 Gradiva finds the anthropomorphic ruins** 1931
Oil on canvas, 65 × 54
*Thyssen-Bornemisza Collection, Lugano*

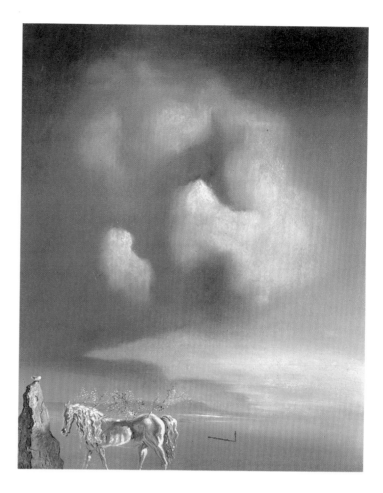

**67 Vegetable metamorphosis** 1931
Oil on canvas, 41 × 32.5
*Private collection*

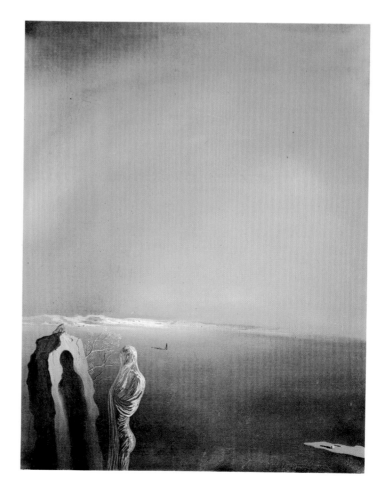

**68 Ambivalent image** 1933
Oil on canvas, 65 × 54
*François-Xavier Petit*

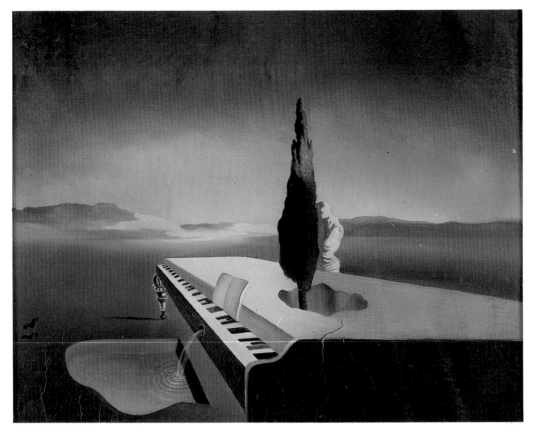

**71 Necrophiliac spring flowering
from a piano with tail** 1933
Oil on canvas, 27 × 22
*Prince J. L. de Faucigny-Lucinge*

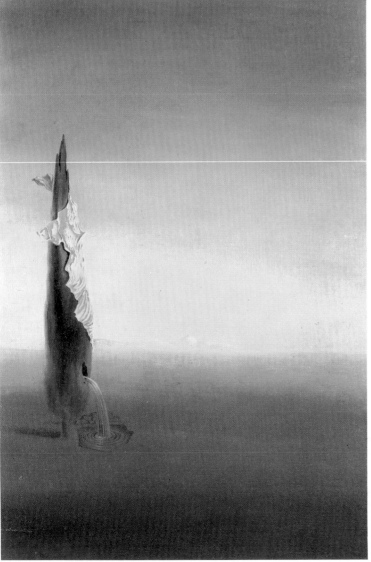

**70 The birth of liquid anxieties** 1932
Oil on canvas, 55 × 38.5
*Davlyn Gallery, New York*

72 **The triangular hour** 1933
Oil on canvas, 61 × 46
*Armand Chatelard*

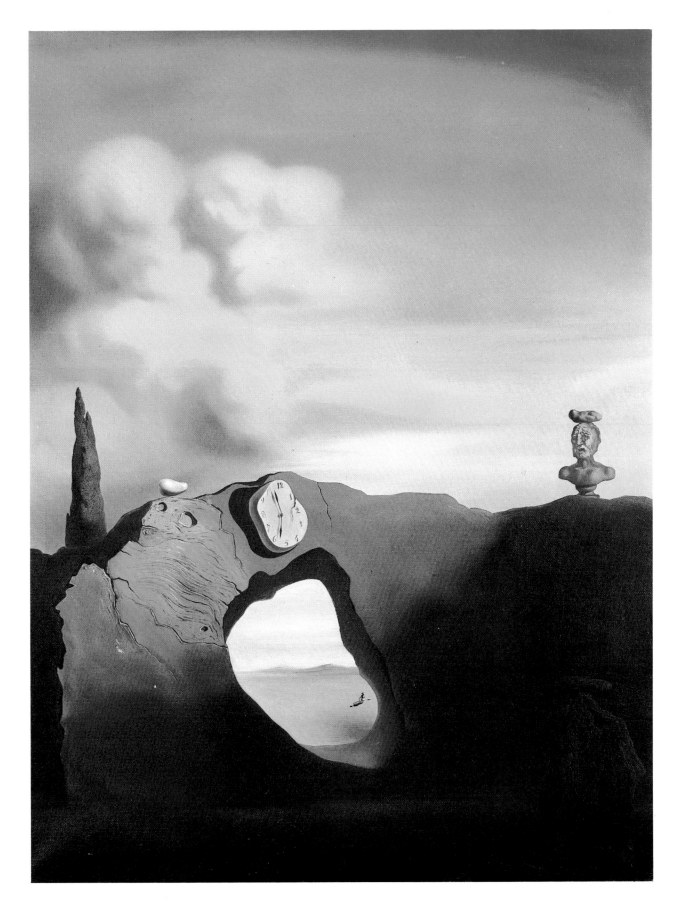

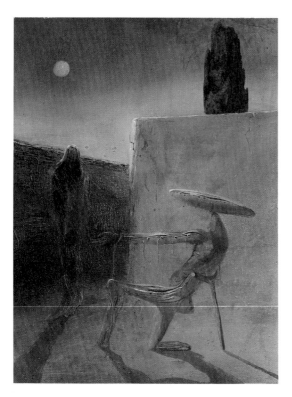

x **The ghost of Vermeer at Delft** *c.*1934
Oil on canvas, 23 × 19
*Private collection*

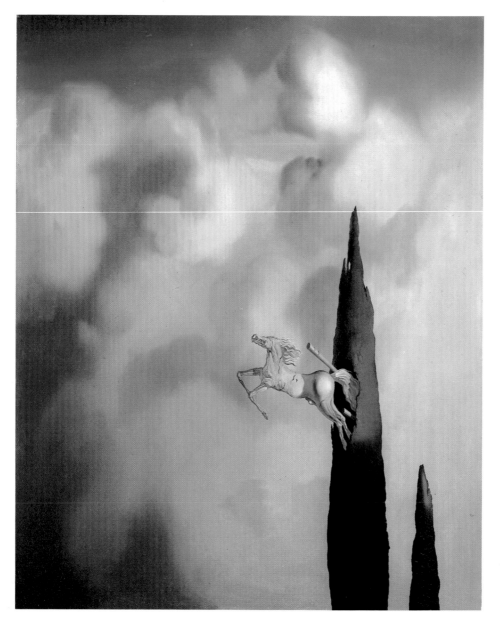

viii **Morning ossification of the
cypress tree** 1934
Oil on canvas, 83 × 66
*Private collection*

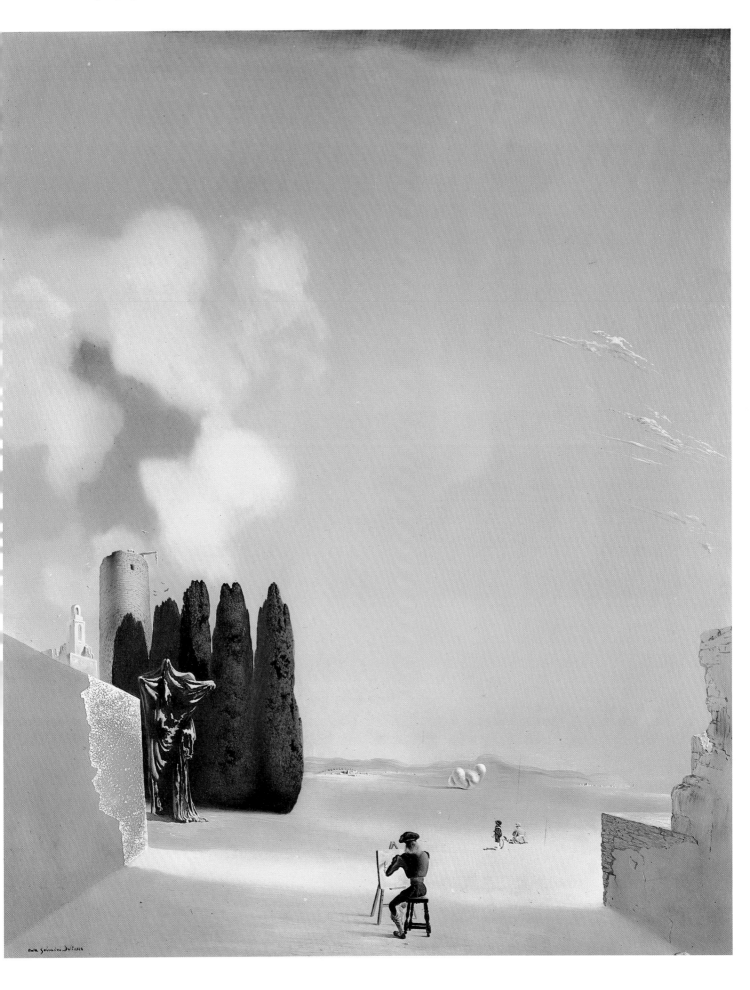

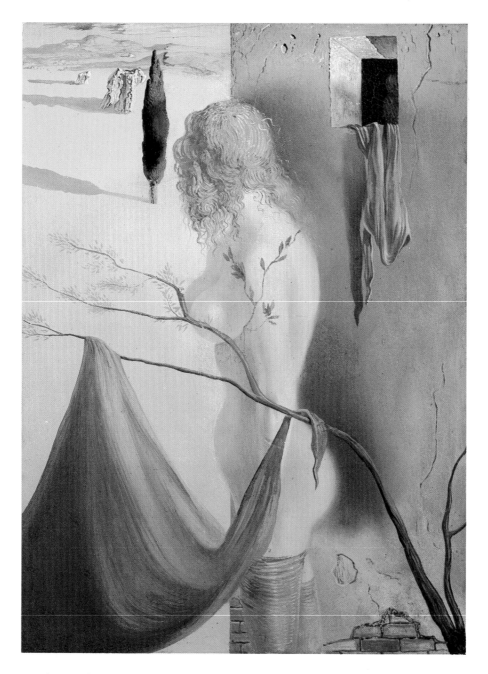

77 **The signal of anguish** 1936
Oil on wood, 22.2 × 16.5
*Private collection*

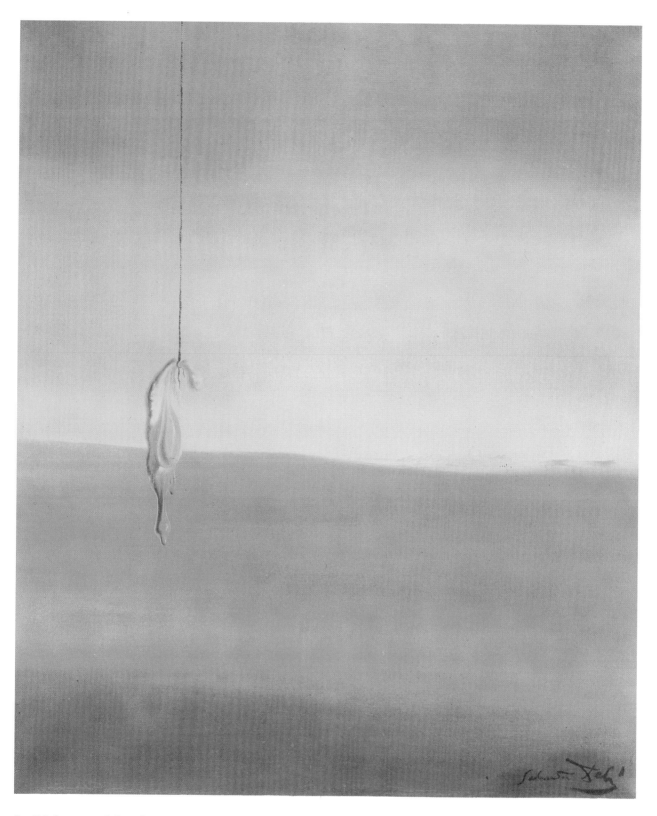

**80 Fried egg on a dish without the dish**
Oil on canvas, 55 × 46
*Davlyn Gallery, New York*

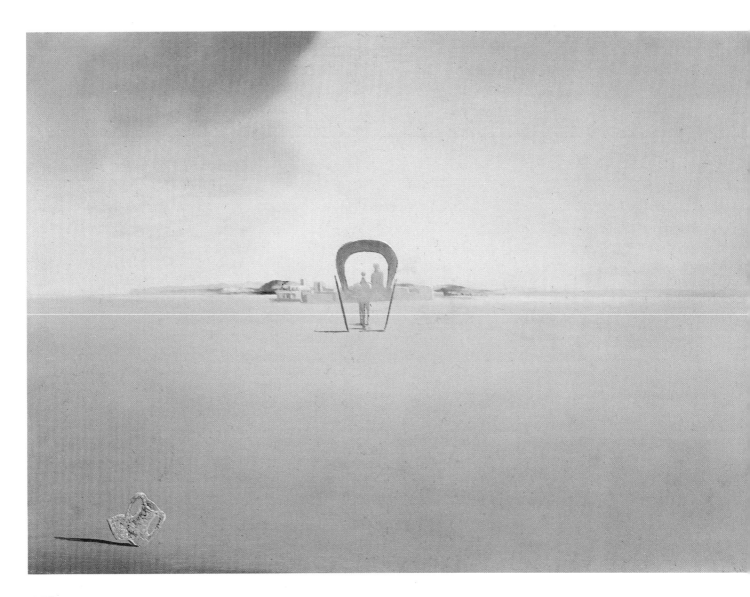

**xi Phantom waggon** 1933
Oil on canvas, 16 × 20.3
*Yale University Art Gallery, New Haven*
*(Gift of Thomas F. Howard)*

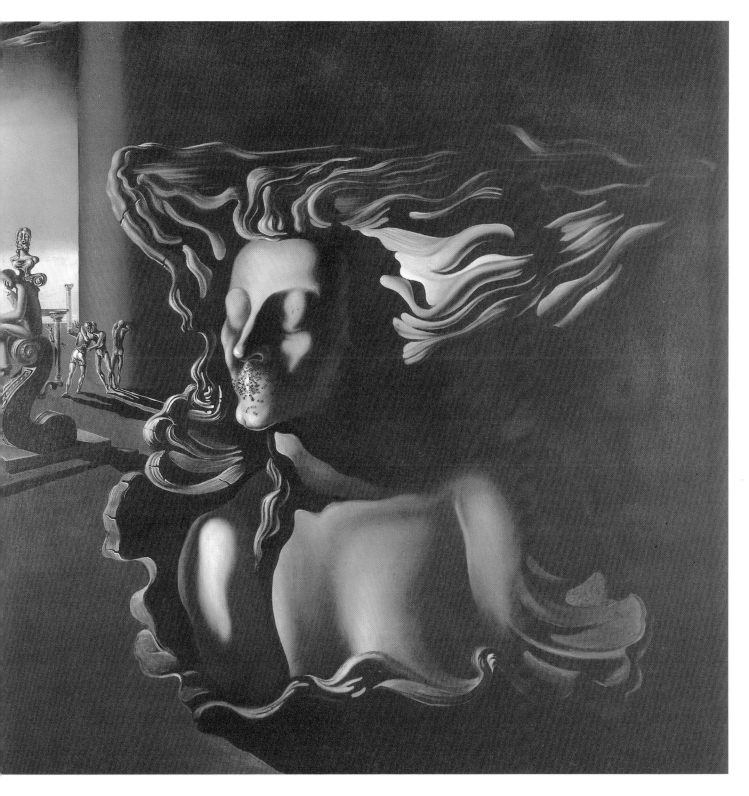

**82 Dream** 1931
Oil on canvas, 96 × 96
*Private collection*

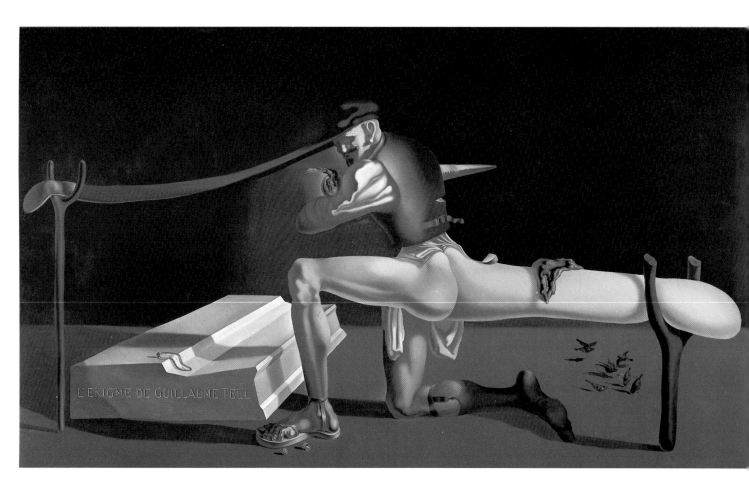

**84 The enigma of William Tell** 1933
Oil on canvas, 201.5 × 346
*Moderna Museet, Stockholm*

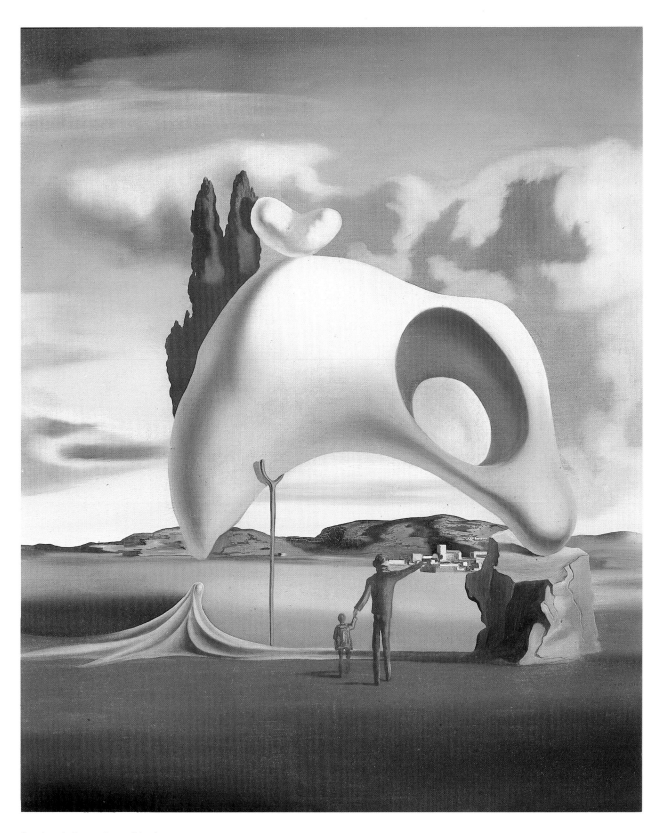

**85 Atavistic vestiges after the rain** 1934
Oil on canvas, 64 × 53
*Perls Galleries, New York*

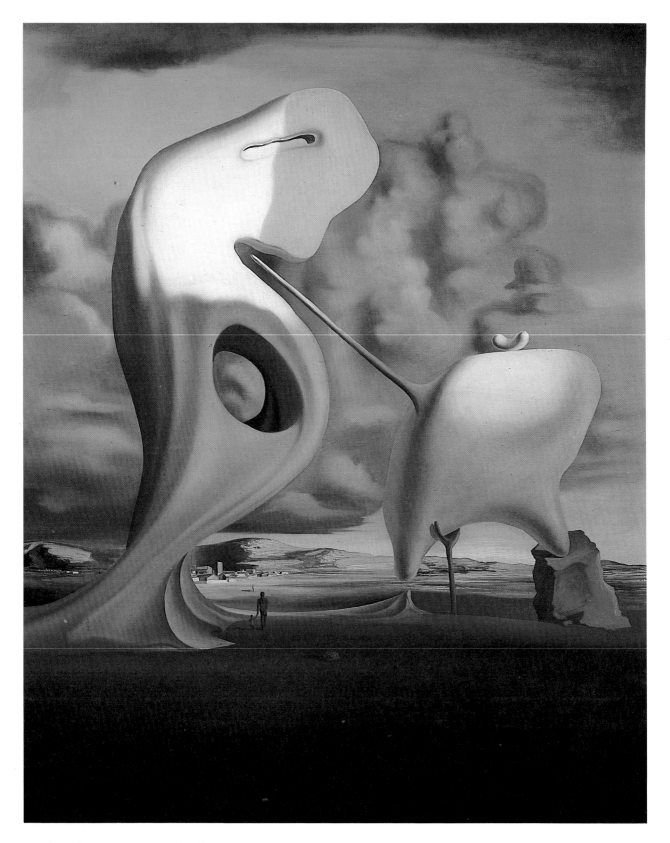

86 **The architectonic Angelus of Millet** 1933
Oil on canvas, 73 × 60
*Perls Galleries, New York*

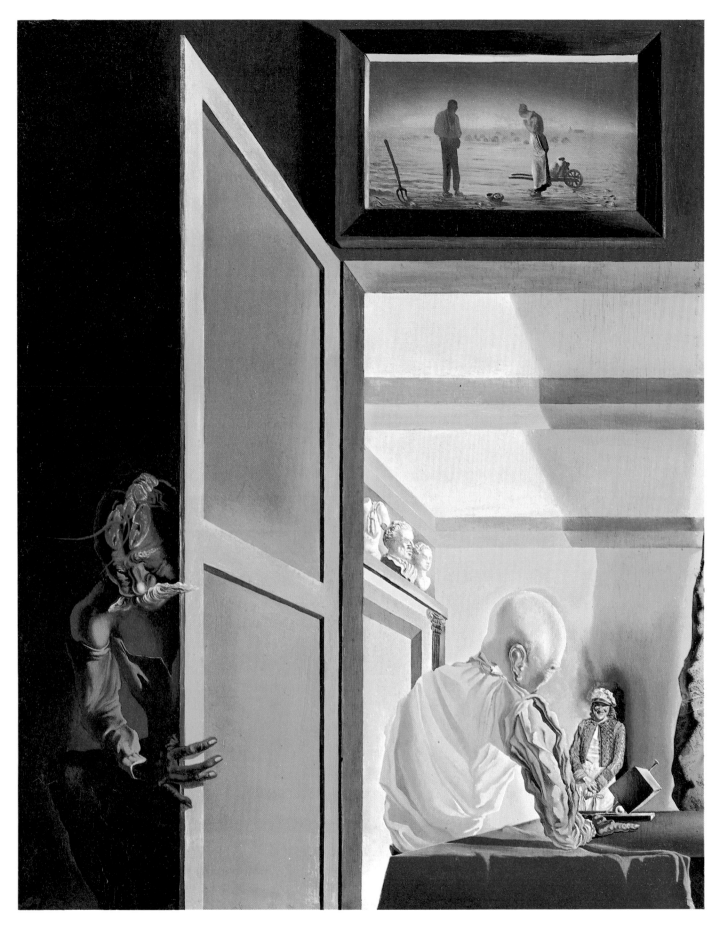

**87 Gala and the Angelus of Millet before
the imminent arrival of the conical
anamorphoses** 1933
Oil on panel, 24 × 18.8
*National Gallery of Canada, Ottawa*

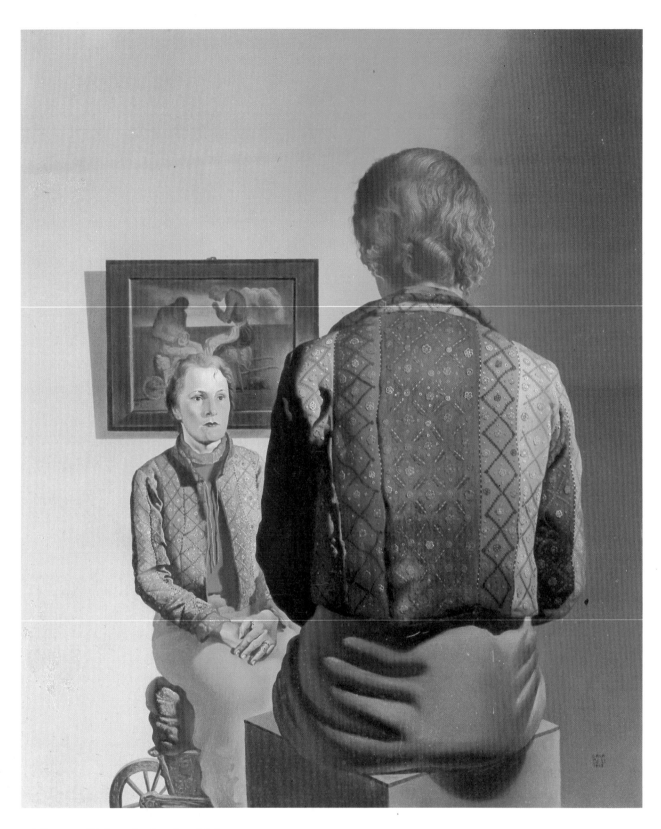

**xvi Portrait of Gala or the Angelus of Gala**
Oil on canvas, 32.4 × 26.7
*Museum of Modern Art, New York*
*(Gift of Abby Aldrich Rockefeller, 1937)*

**95 Nostalgia of the cannibal** 1932
Oil on canvas, 47.2 × 47.2
*Kunstmuseum Hannover mit Sammlung*
*Sprengel*

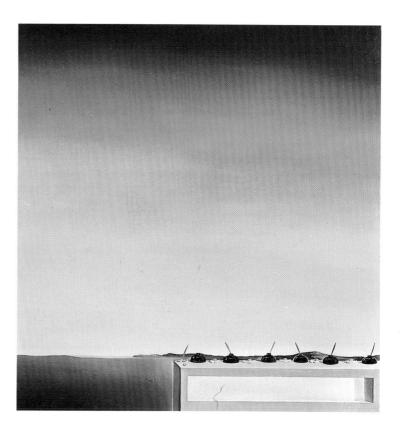

**6 Partial hallucination: six apparitions of**
**Lenin on a piano** 1931
Oil on canvas, 114 × 146
*Musée National d'Art Moderne – Centre*
*Georges Pompidou, Paris*

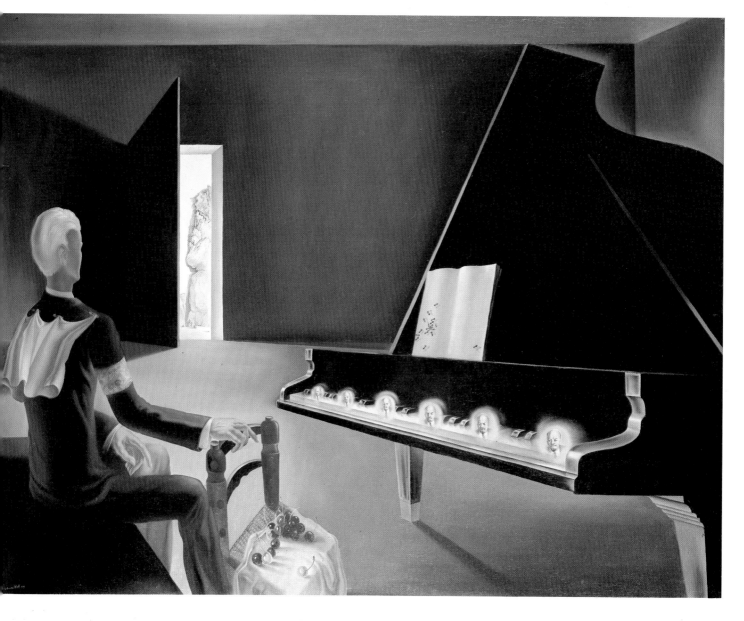

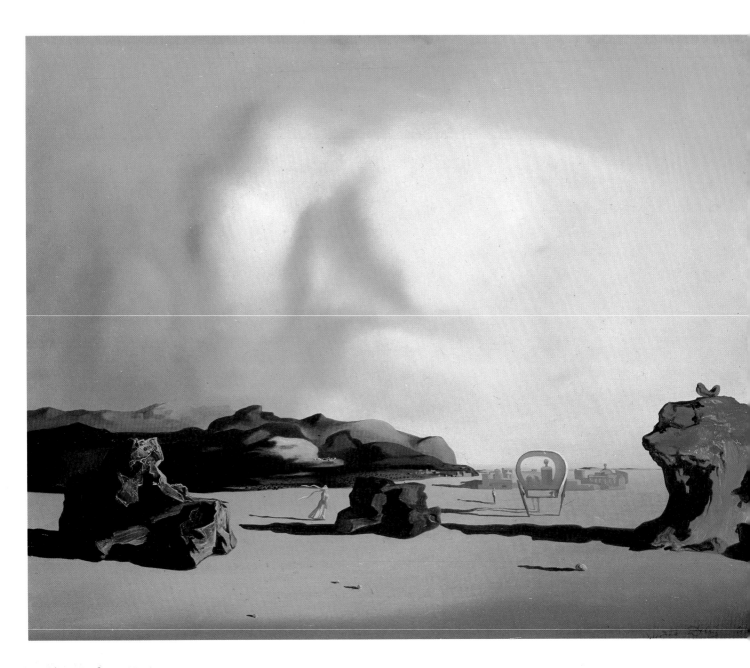

**97 Moment of transition** 1934
Oil on canvas, 54 × 65
*Private collection*

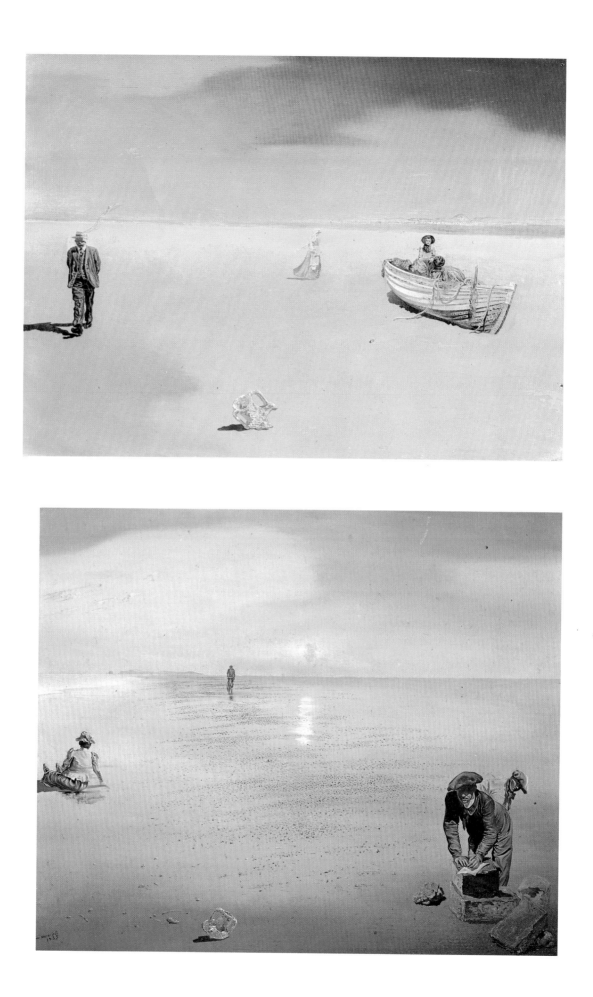

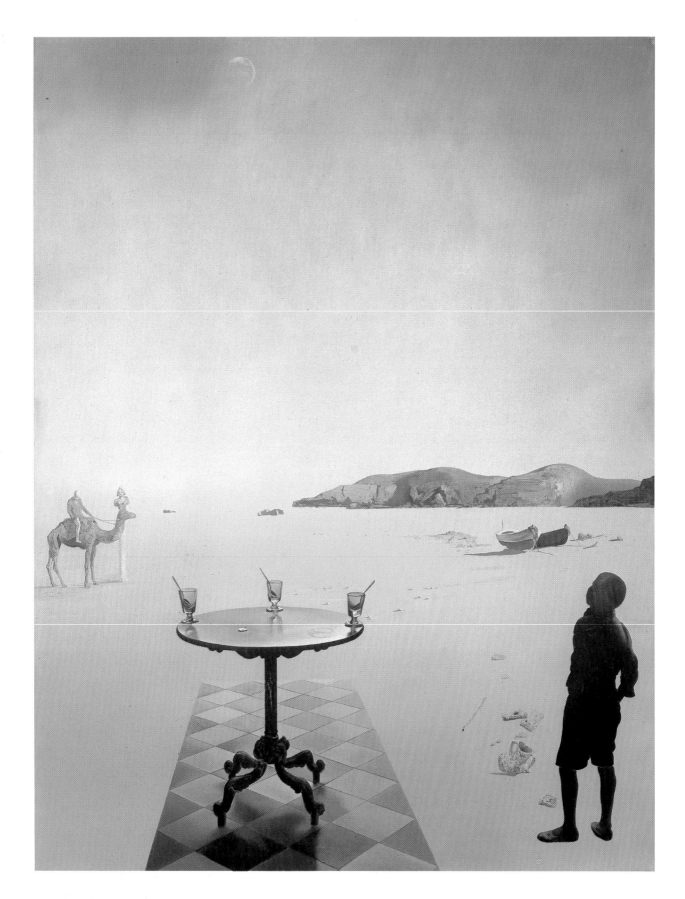

**102  The solar table**  1936
  Oil on wood, 60 × 46
  *Boymans-van Beuningen Museum,*
  *Rotterdam*

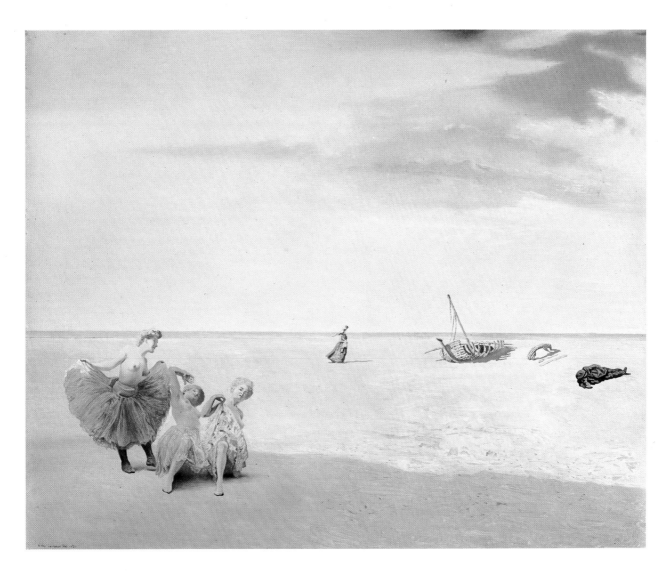

104  **Forgotten horizon** 1936
     Oil on wood, 22 × 26.5
     *Tate Gallery, London*

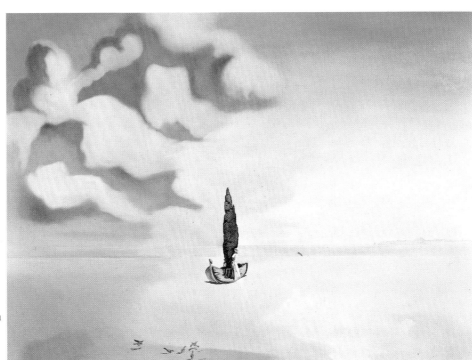

05  **Apparitions of my cousin Carolinetta
    on the beach at Rosas** 1934
    Oil on canvas, 73 × 100
    *Private collection*

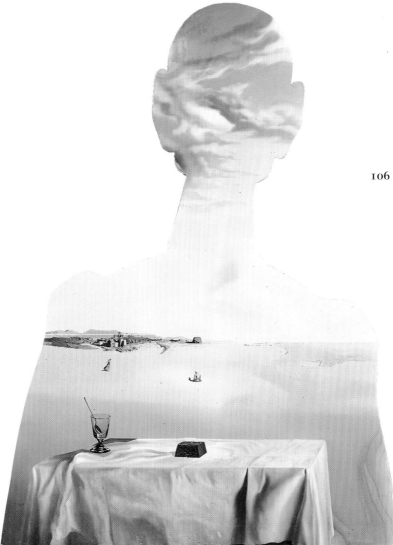

106 **Couple with heads full of clouds**
Oil on wood, man 92.5 × 62.5
woman 82.5 × 62.5
*Boymans-van Beuningen Museum,*
*Rotterdam*

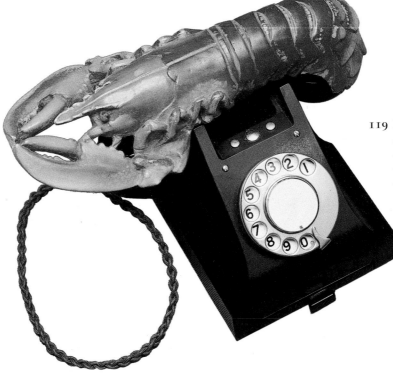

119 **Lobster telephone** 1936
Assemblage, 30 × 15 × 17
*Edward James Foundation on loan to*
*Boymans-van Beuningen Museum,*
*Rotterdam*

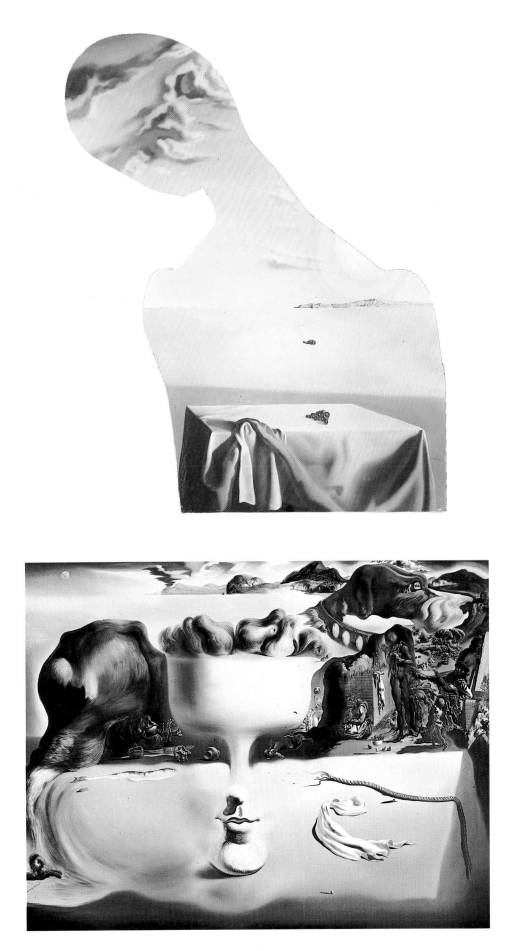

**142  Apparition of face and fruit dish on a beach** 1938
Oil on canvas, 114.8 × 143.8
*Wadsworth Atheneum, Hartford,*
*Connecticut (the Ella Gallup Sumner and*
*Mary Catlin Sumner Collection)*

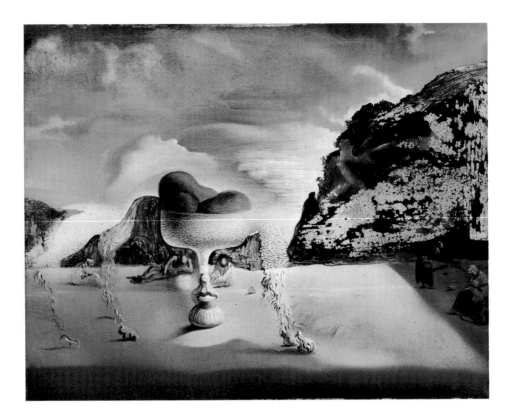

143 Invisible Afghan with apparition, on
   the beach, of the face of Garcia Lorca in
   the form of a fruit dish with three figs
   1938
   Oil on wood, 19.2 × 24.1
   *Private collection*

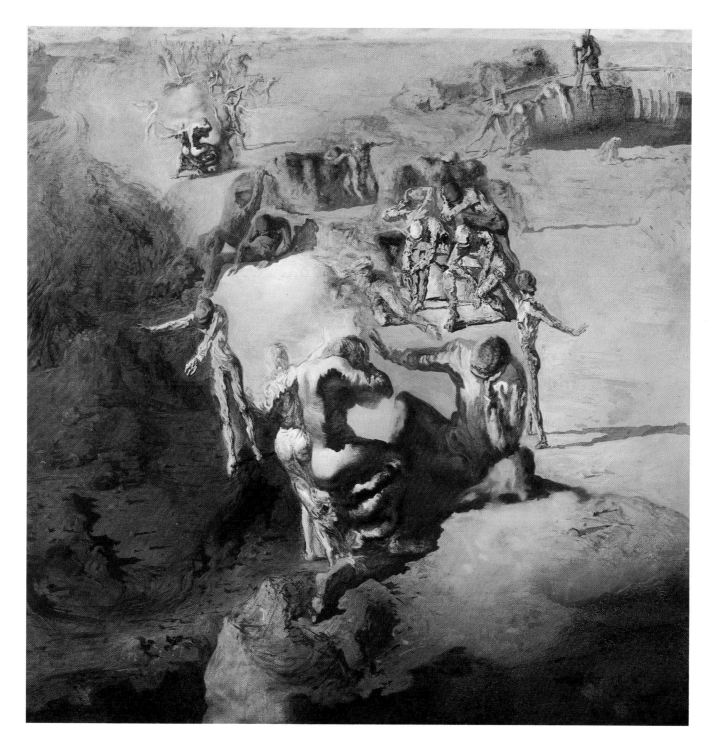

**149 The Great paranoiac** 1936
Oil on canvas, 62 × 62
*Boymans-van Beuningen Museum,*
*Rotterdam*

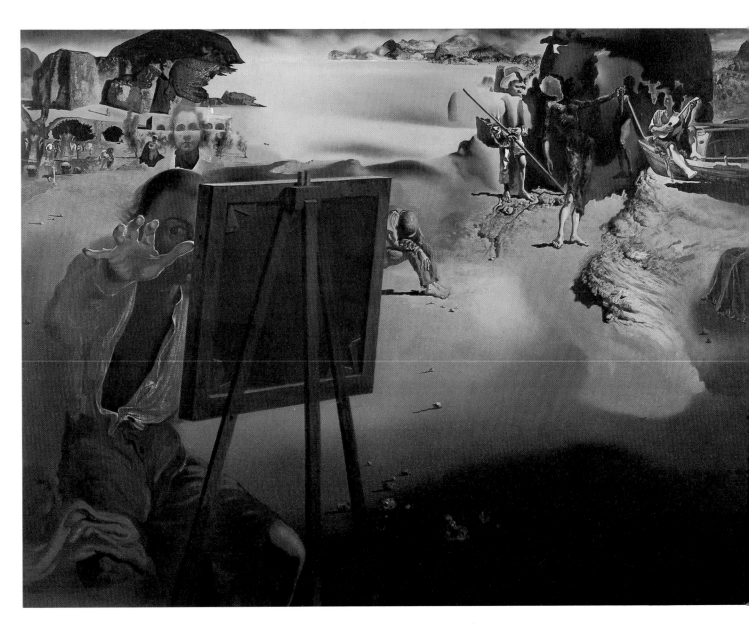

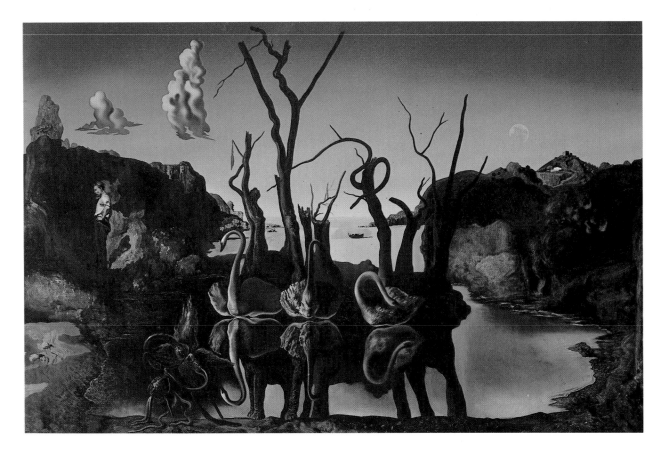

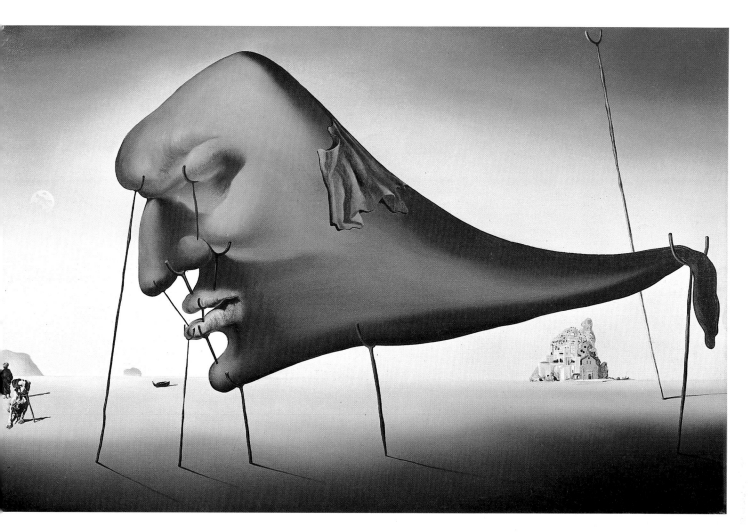

**155 Sleep** 1937
Oil on canvas, 50 × 77
*E. F. W. James on loan to the Boymans-*
*van Beuningen Museum, Rotterdam*

*Opposite page top*
**50 Impressions of Africa** 1938
Oil on canvas, 91.5 × 117.5
*Boymans-van Beuningen Museum,*
*Rotterdam*

*Opposite page below*
**53 Swans reflecting elephants** 1937
Oil on canvas, 51 × 77
*Cavalieri Holding Co. Inc., Geneva*

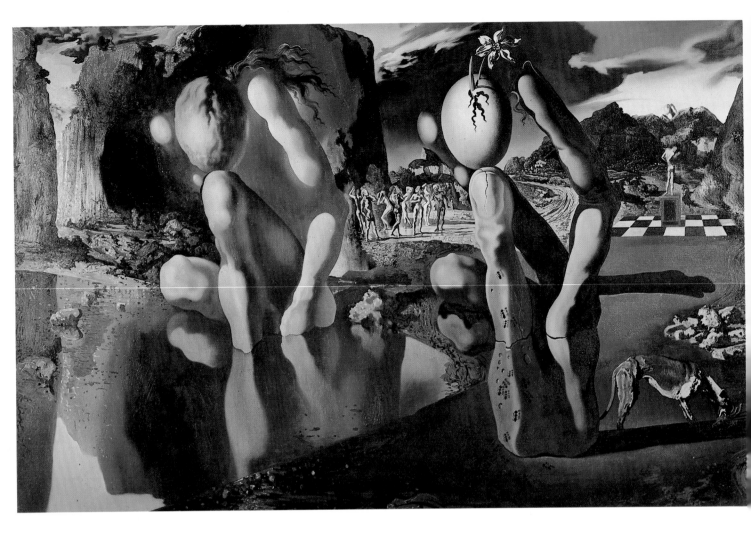

**156  Metamorphosis of Narcissus**  1937
Oil on canvas, 50.8 × 78.2
*Tate Gallery, London*

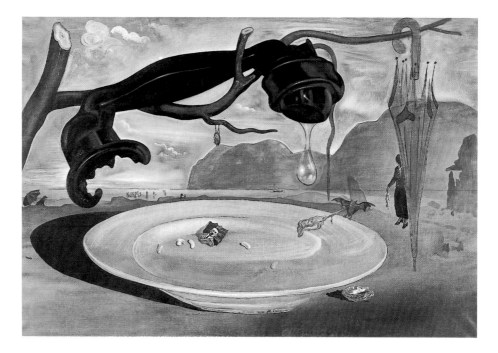

160  **The enigma of Hitler**  1937
Oil on wood, 94 × 141
*Private collection*

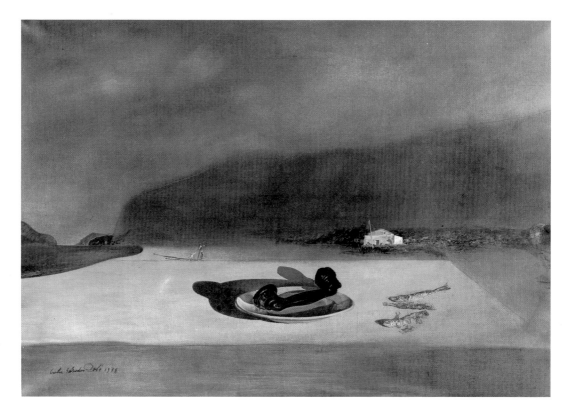

xv  **Imperial violets**  1938
Oil on canvas, 99.5 × 142.5

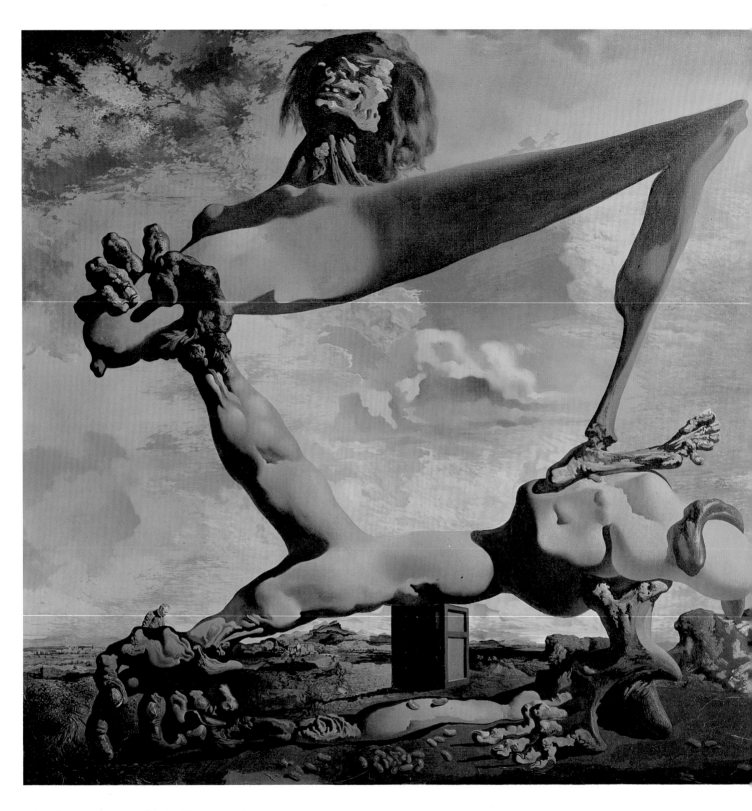

**xiv  Soft construction with boiled beans**  1936
Oil on canvas, 100 × 99
*Philadelphia Museum of Art*

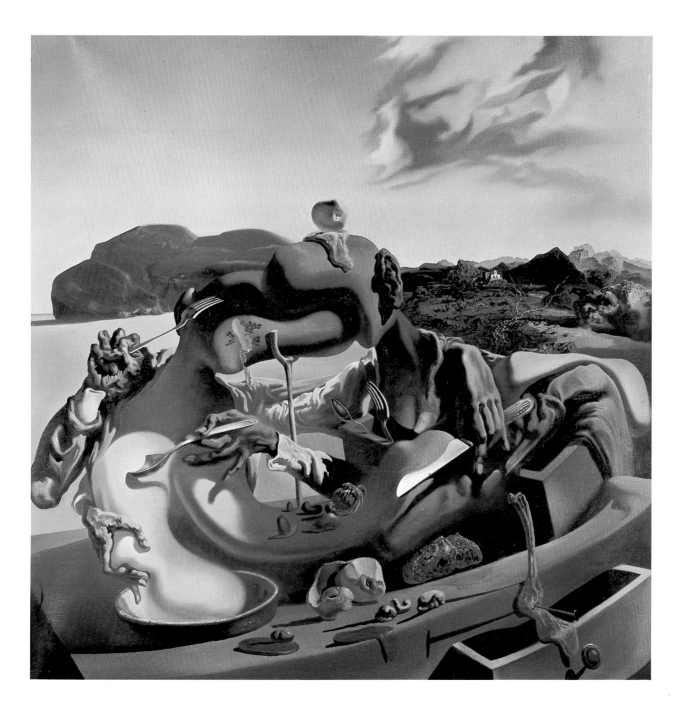

**158 Autumn cannibalism** 1936–7
Oil on canvas, 65 × 65.2
*Tate Gallery, London*

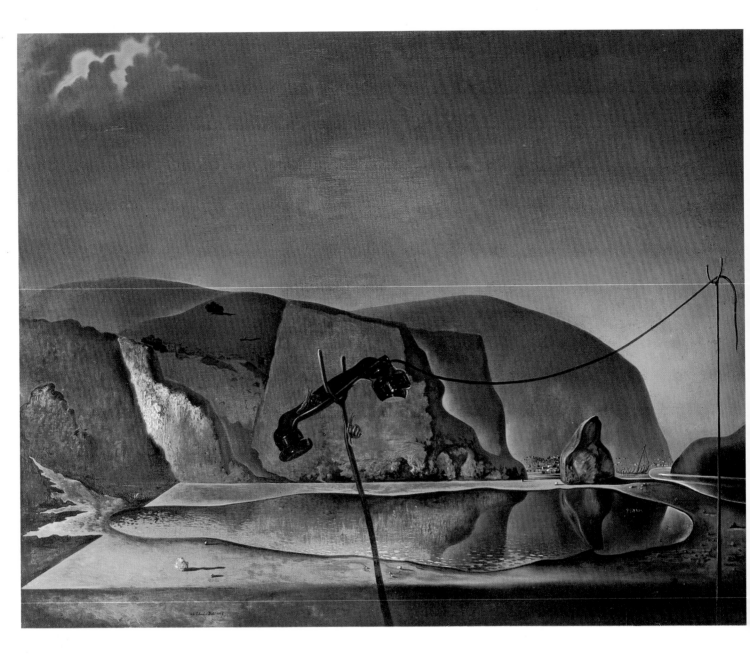

**161 Mountain lake** 1938
Oil on canvas, 73 × 92
*Tate Gallery, London*

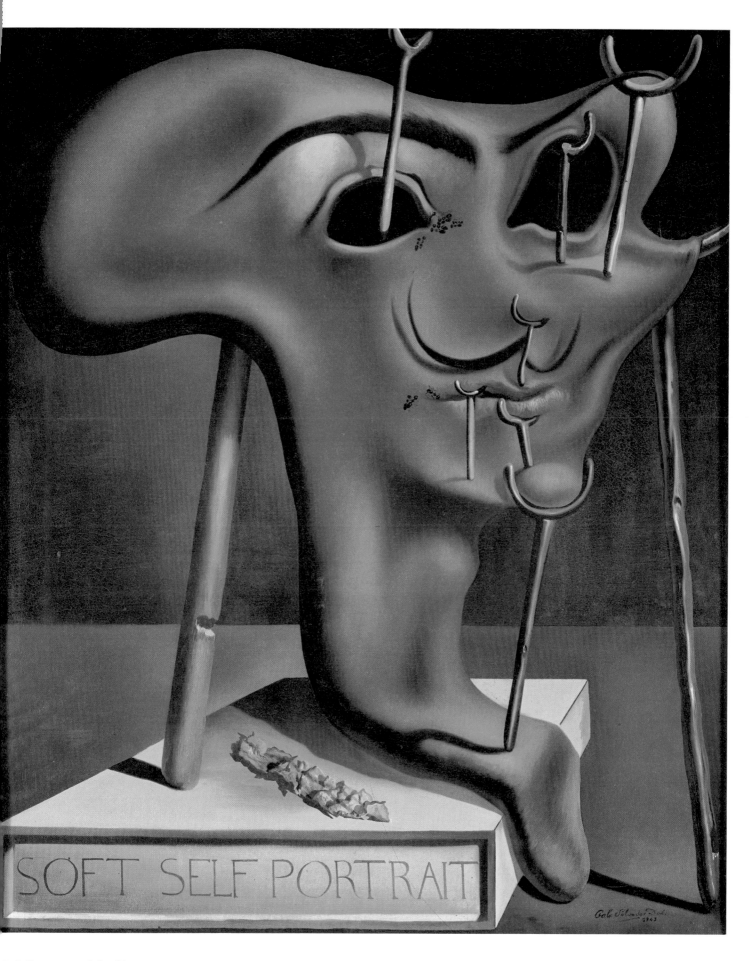

SOFT SELF PORTRAIT

**ii Self portrait with fried bacon**
Oil on canvas, 61 × 50.8
*Private collection*

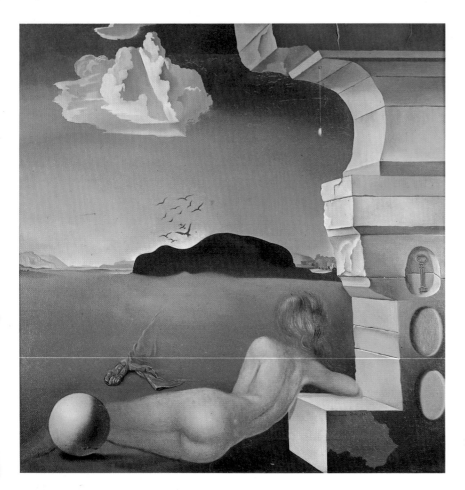

xiii **Nude on the plain of Rosas** 1942
Oil on canvas, 50 × 50
*Mme P. de Garardie, Paris*

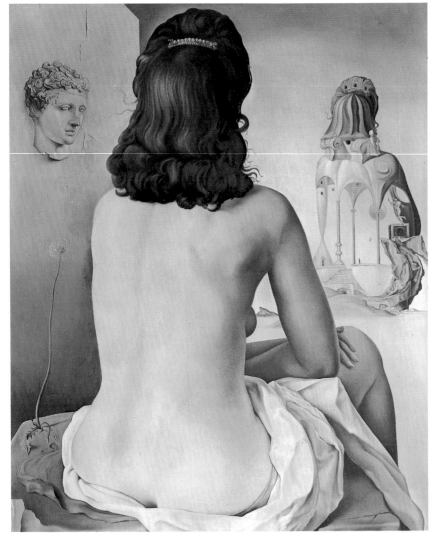

*Left*
198 **My wife, nude, contemplating her own
flesh becoming stairs, three vertebrae
of a column sky and architecture** 1945
Oil on wood, 61 × 52
*Mr and Mrs Enrique Corcuera*

*Opposite page*
xvii **Young virgin autosodomised by her own
chastity** 1954
Oil on canvas, 40.5 × 30.5

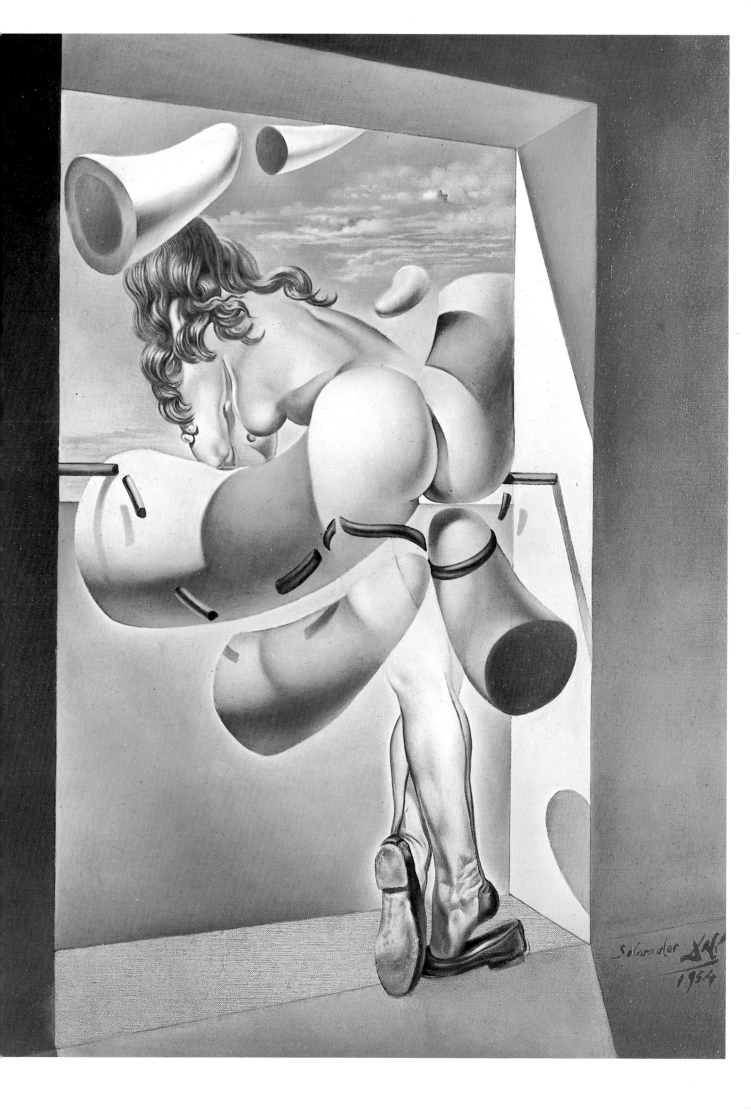

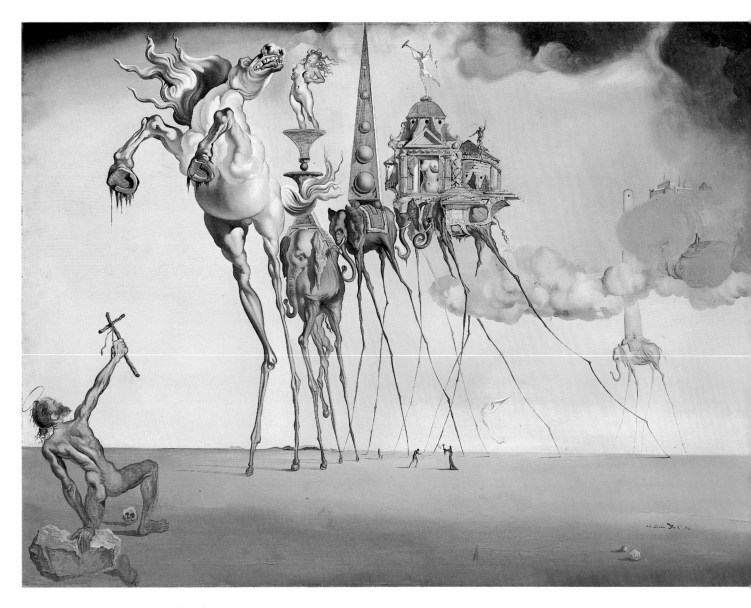

**199  The temptation of Saint Anthony**  1946
Oil on canvas, 89.7 × 119.5
*Musées Royaux des Beaux Arts de*
*Belgiques, Brussels*

200 **Dream caused by the flight of a bee**
   **around a pomegranate one second**
   **before waking up** 1944
   Oil on canvas, 51 × 41
   *Thyssen-Bornemisza Collection, Lugano*

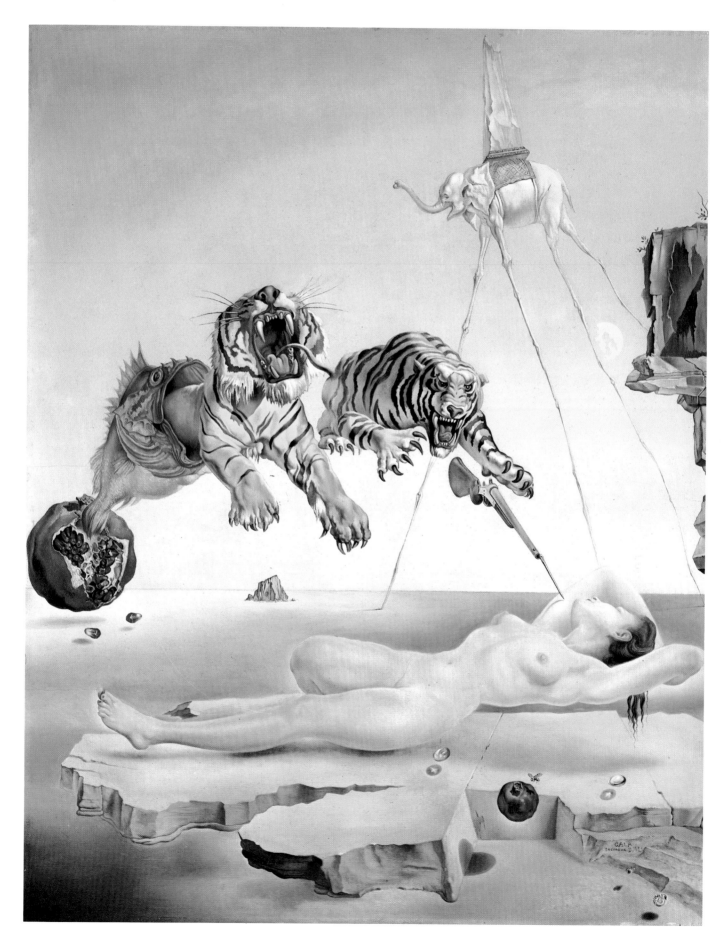

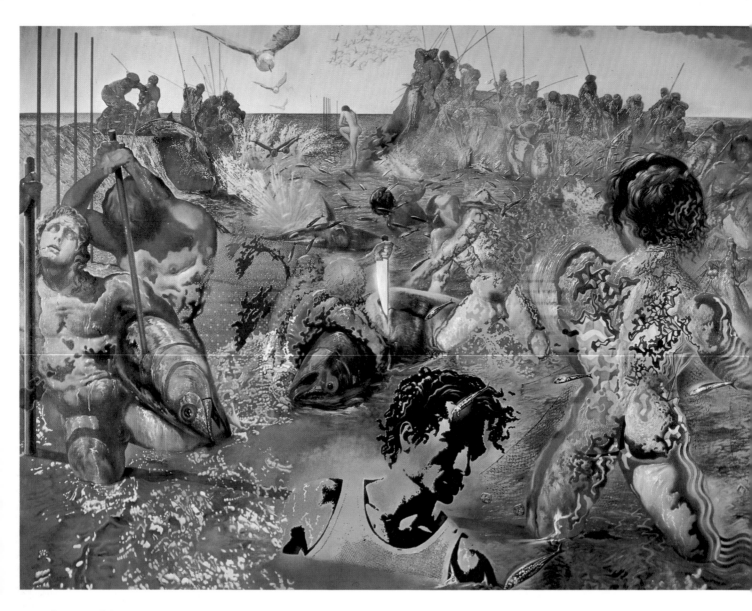

**xviii  The tunny fisher**  1966–7
Oil on canvas, 400 × 300
*Paul Ricard Foundation*

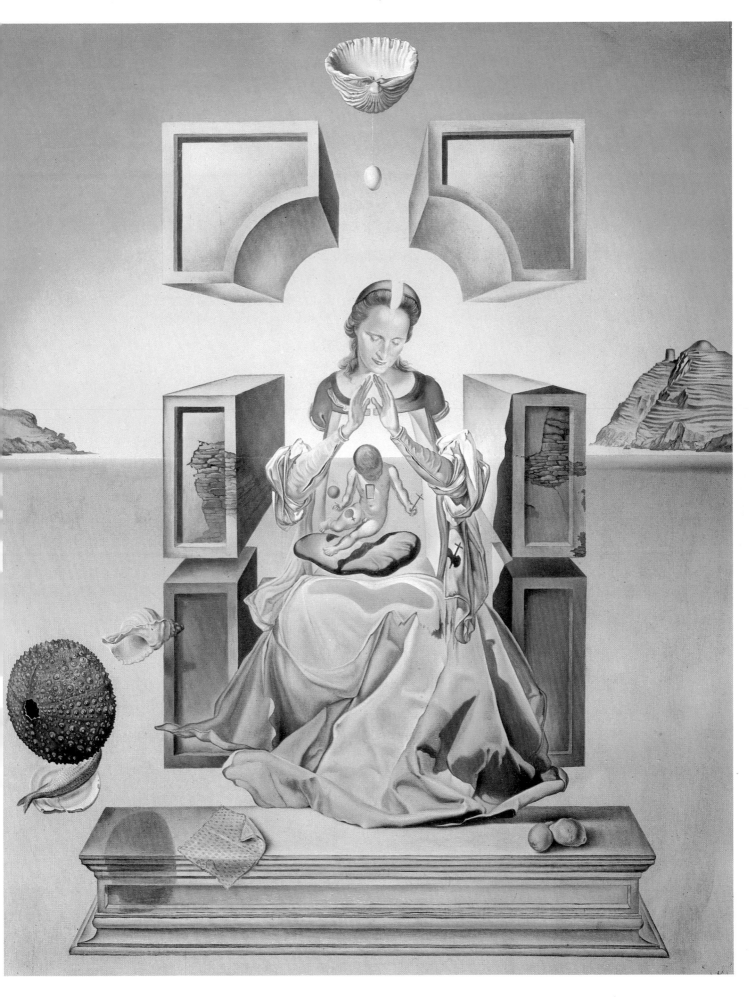

**213 First study for the 'Madonna of Port Lligat'** 1949
Oil on canvas, 48.9 × 37.5
*Marquette University Committee on the Fine Arts*

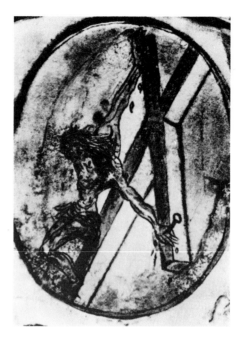

*Above*
**xxix Drawing of Christ attributed
to St John of the Cross**
*Avila, Spain*

*Opposite page*
**215 Christ of St John of the cross** 1951
Oil on canvas, 205 × 116
*Glasgow Art Gallery*

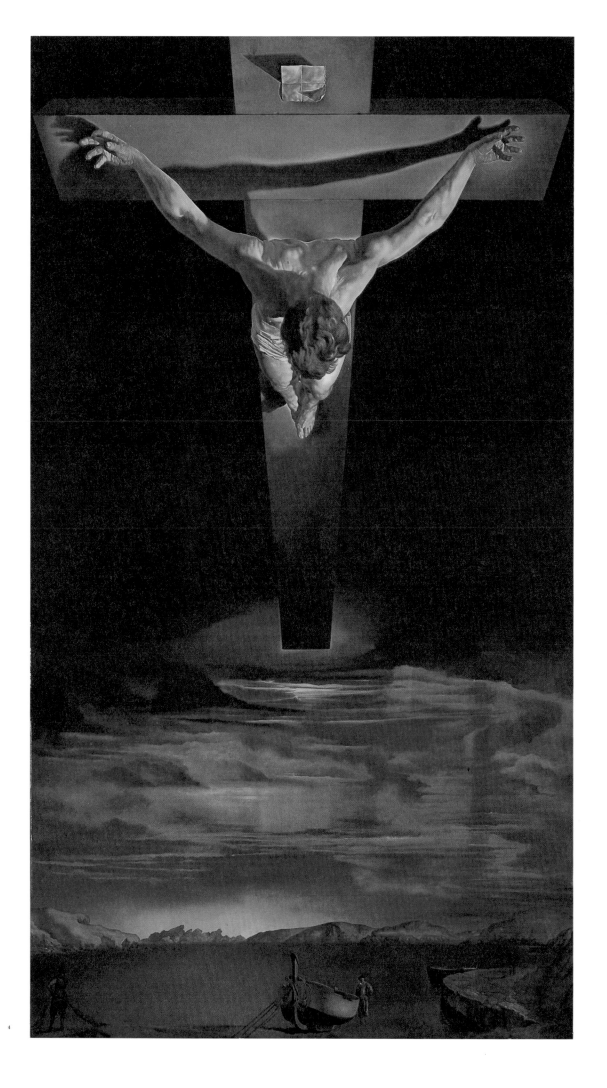

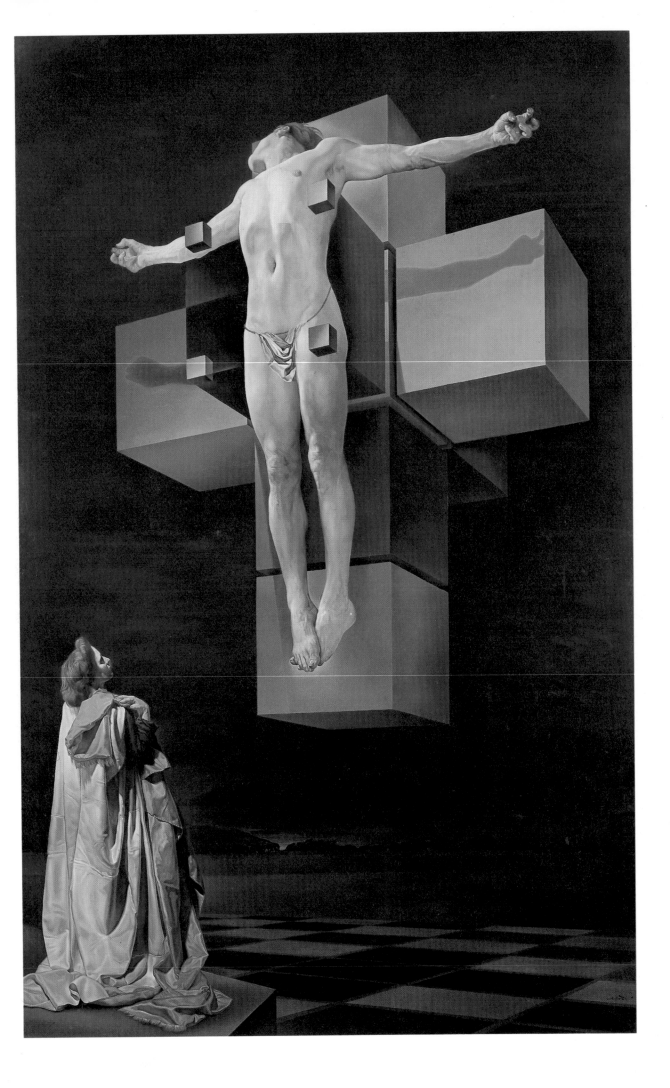

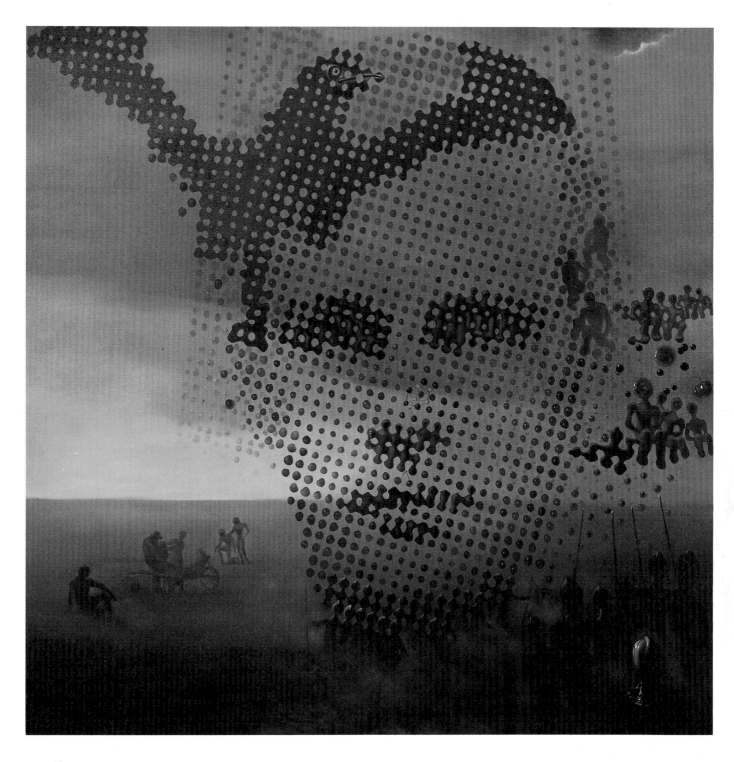

*Above*

**218 Portrait of my dead brother** 1963
Oil on canvas, 190 × 190
*Private collection*

*Opposite page*

**216 Crucifixion or Corpus hypercubicus**
1954
Oil on canvas, 194.5 × 124
*Metropolitan Museum of Art, New York*
*(Gift of the Chester Dale Collection)*

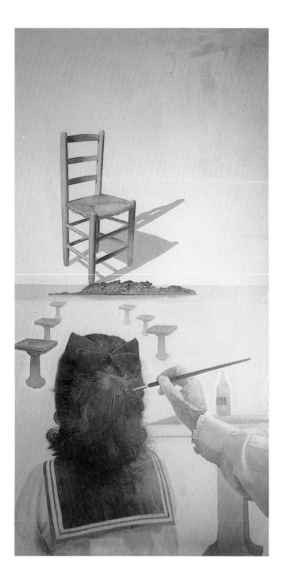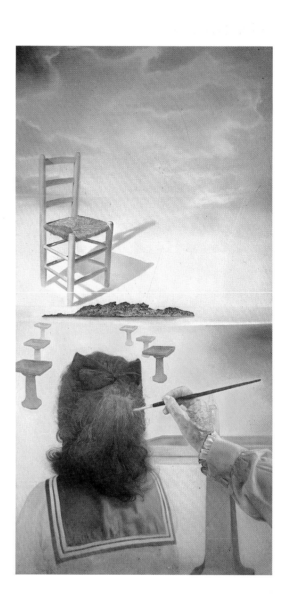

**236 The chair** 1975
   Stereoscopic painting in two sections
   Oil on canvas, each 400 × 210
   *Private collection*

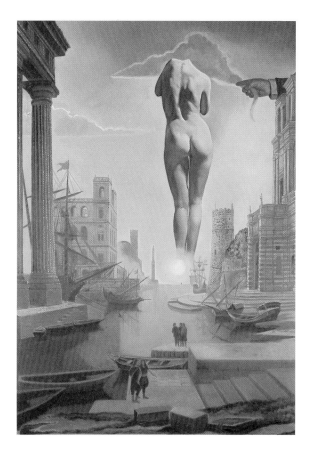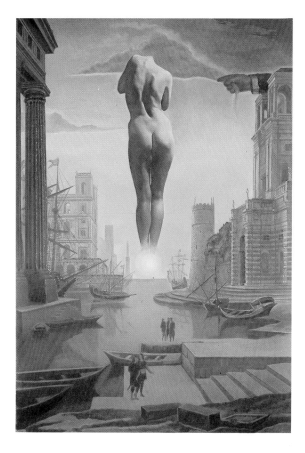

240 **Dali's hand raising a gold veil in
the shape of a cloud to show Gala the
naked dawn far beyond the sun
(Homage to Claude Lorrain)** 1977
Stereoscopic painting in two sections
Oil on canvas, each 60 × 60
*Private collection*

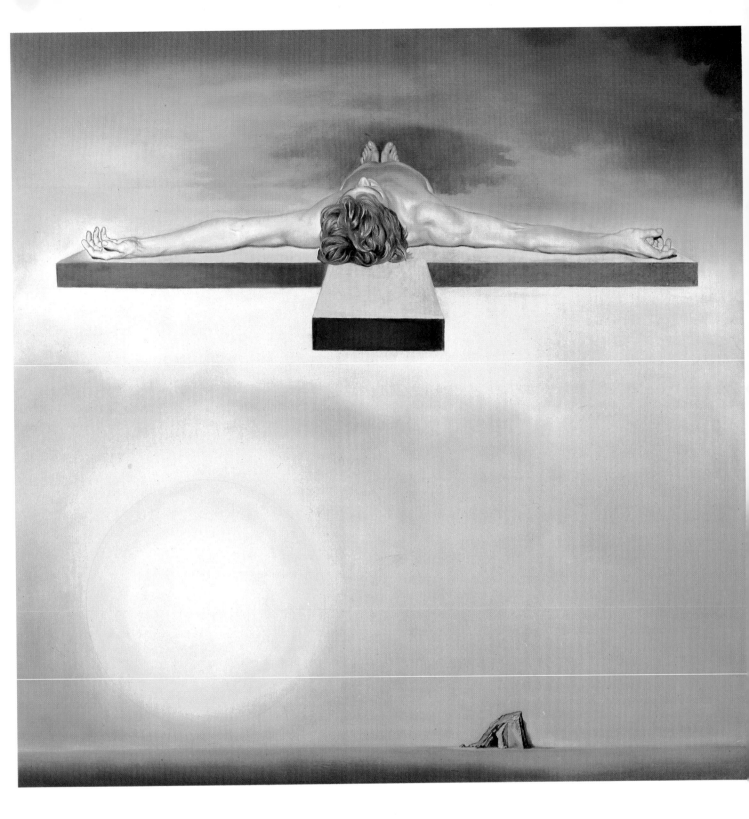

**247  The Christ of Gala**  1978
Stereoscopic painting in two sections
Oil on canvas, each 100 × 100
*Center Art Gallery, Honolulu*

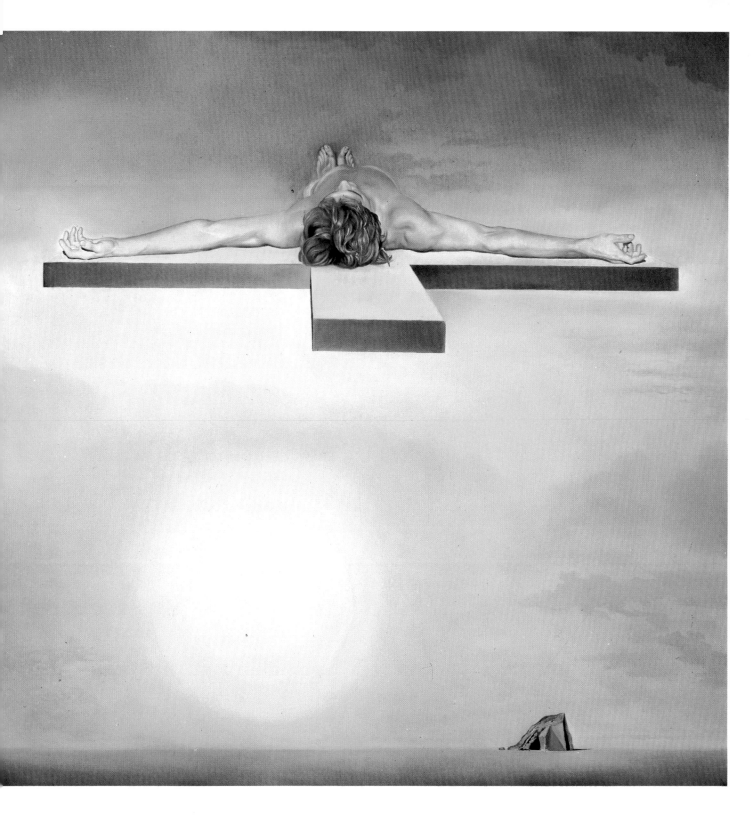

**206 St Cecilia the ascensionist** 1955
Oil on canvas, 81 × 66
*Private collection*